FIRST STEPS
SERIES

Sketching and Drawing

CATHY JOHNSON

NORTH LIGHT BOOKS

Cincinnati, Ohio

Acknowledgments

This book, like all books, is the product of many minds and hands. The author is grateful for help both with this project and with the concept of drawing itself. Other inveterate sketchers, like Keith and Roberta Hammer, Judy Gehrlein, Clare Walker Leslie, Ann Zwinger, and Hannah Hinchmann, have provided inspiration and encouragement. My editor, Greg Albert, and editorial director David Lewis, have provided direction, support and motivation. My thanks to all.

Sketching and Drawing. Copyright ©1995 by Cathy A. Johnson. Printed and bound in Hong Kong. All rights reserved. No part of this book may be reproduced in any form or by any electronic or mechanical means including information storage and retrieval systems without permission in writing from the publisher, except by a reviewer, who may quote brief passages in a review. Published by North Light Books, an imprint of F&W Publications, Inc., 1507 Dana Avenue, Cincinnati, Ohio 45207. 1-800-289-0963. First edition.

Other fine North Light Books are available from your local bookstore, art supply store or direct from the publisher.

99 98 97 96 5 4 3 2

Library of Congress Cataloging-in-Publication Data

Johnson, Cathy (Cathy A.)
 Sketching and drawing / by Cathy Johnson.
 p. cm. — (First steps series)
 Includes index.
 ISBN 0-89134-615-5 (pb : acid-free paper)
 1. Drawing—Technique. I. Title. II. Series: First steps series
 (Cincinnati, Ohio)
NC730.J64 1995
741.2—dc20 95-10607
 CIP

Edited by Greg Albert
Designed by Brian Roeth

METRIC CONVERSION CHART

TO CONVERT	TO	MULTIPLY BY
Inches	Centimeters	2.54
Centimeters	Inches	0.4
Feet	Centimeters	30.5
Centimeters	Feet	0.03
Yards	Meters	0.9
Meters	Yards	1.1
Sq. Inches	Sq. Centimeters	6.45
Sq. Centimeters	Sq. Inches	0.16
Sq. Feet	Sq. Meters	0.09
Sq. Meters	Sq. Feet	10.8
Sq. Yards	Sq. Meters	0.8
Sq. Meters	Sq. Yards	1.2
Pounds	Kilograms	0.45
Kilograms	Pounds	2.2
Ounces	Grams	28.4
Grams	Ounces	0.04

Dedication

To Harris, who supports me in all I do.

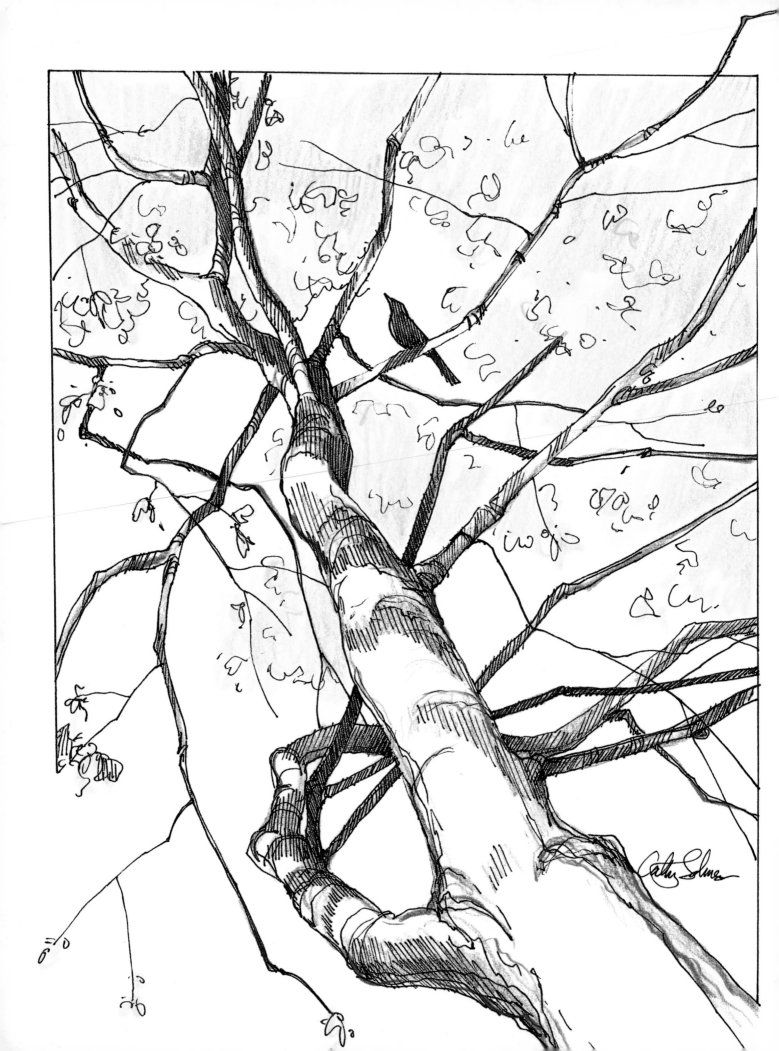

Table of Contents

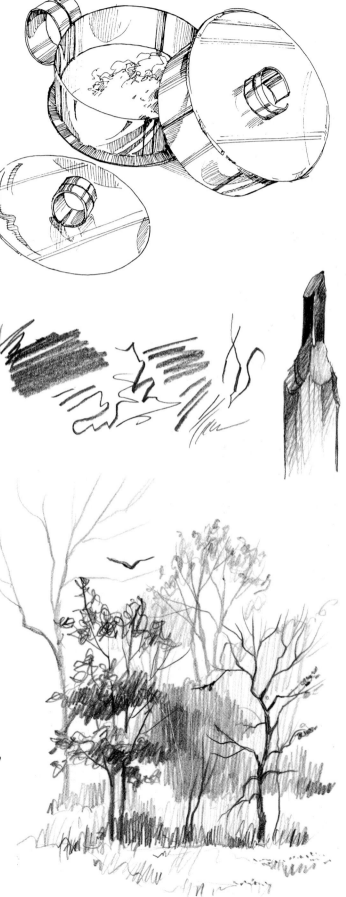

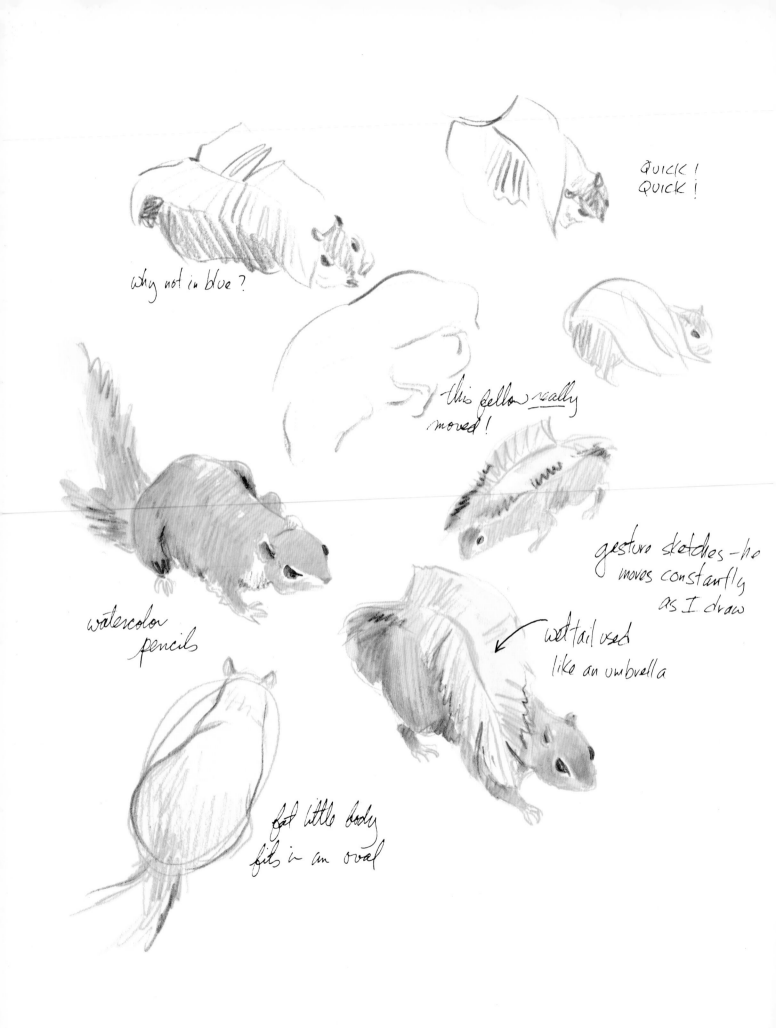

QUICK!
QUICK!

why not in blue?

this fellow really
moved!

gesture sketches—he
moves constantly
as I draw

wet tail used
like an umbrella

watercolor
pencils

fat little body
fits in an oval

Introduction

Drawing is one of the most satisfying and immediate ways of making art. Even a toddler knows that, when she picks up that first crayon to scribble on your wall. It's almost instinctive, and it's one of our best—and first—ways to communicate with one another. People love to draw—what's more, they *need* to draw.

But best of all, drawing is fun. Whether you jot down a few quick lines to capture your playing cat or spend hours trying to depict just that perfect pattern of lights and darks you see before you, drawing is enjoyable and satisfying.

"But I can't draw a straight line," you say? Well, neither can I, without a ruler; and who cares, anyway? How many straight lines are there in nature?

"I can't draw at *all*," you say? Well, I doubt that's true. You already have the most important element—you *want* to draw, or you wouldn't be holding this book. Why is it we expect everyone to learn to read, but we think drawing is magic attainable by the gifted few?

Sure, it's easier for some people than for others: Driving comes easier to some people, too—so does dancing, or cooking. The same holds true for drawing. You can do it—just take it a step at a time. Each time you master one thing, it becomes easier to move on to the next.

So pick up that pencil—and recognize it for what it is: a magic wand capable of pulling an image right up out of a blank sheet of paper. And *you* are the wizard who can pull it off!

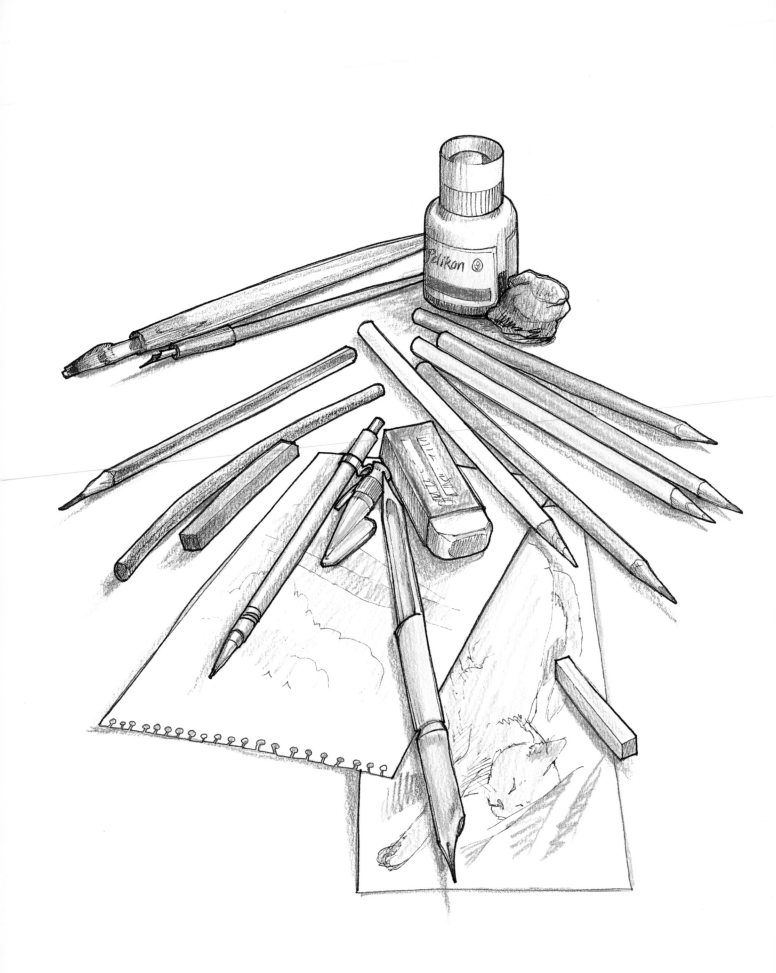

Chapter One

ALL YOU NEED TO GET STARTED

Drawing and sketching require only the simplest of materials—something to draw *on*, and something to draw *with*. Sure, you *can* get a lovely pad of toned paper in a dozen pastel hues and a full set of water-soluble colored pencils (and why *not*?), but there's no need if you don't want to. Start out simply and see how you like it: A small sketch pad and the stubby yellow pencil you used to make your grocery list will do just fine, thank you. Look in your fix-it drawer for the flat carpenter's pencil you got at the lumberyard. An inexpensive, fiber-tipped pen from the grocery store works as well for drawing as writing; if you get a water-soluble one, you can even get subtle tonal effects—we'll show you how later.

The point is, drawing materials can be had just about anywhere. And actually, I don't let the lack of a sketch pad stop me, either; I've been known to sketch on the front of an empty sketchbook; on the back of an envelope; on a napkin at a cafe; and in the margins of minutes of whatever meeting I happen to be in. Never use that old excuse that you don't have the proper materials—we're not painting the Sistine Chapel here. Drawing and sketching is fun, personal, intimate, quick, portable, inexpensive and deeply satisfying. What better place to start?

Getting Started

This is the easy part, because you've already done it. You're interested, or you wouldn't be holding this book. The *desire* to draw or sketch is all it takes to get off to a running start.

Get hold of a book of drawings—maybe those of Rembrandt or Michelangelo. Catch a show of drawings at your local gallery, university or art school. Look through a variety of art books: find those that feature preliminary sketches. What we're looking for here is *inspiration*.

Pay attention to how few lines it really takes to capture a sense of life. Notice, too, that a drawing doesn't have to be technically perfect to be exciting and vital—*that's* what we're after, after all, not cold perfection.

After Rembrandt
"An Inn Beside a Road"

What's the Best Way to Start?

The best way to get started is with a piece of paper and a pencil—along with a desire to catch what you see on paper, to express yourself, to better learn to see the world around us. Drawing is one of the *best* ways to learn to slow down, to pay attention. The record you make for yourself is invaluable.

Look around the house and see what you have to draw with—try out a few quick doodles. When I got back into keeping a sketchbook/journal on a regular basis, I started out with a 5" × 7" pad of drawing paper and a no. 2 office pencil. Granted, these pencils are somewhat limited as to the range of lights and darks you can get, but they're accessible and inexpensive. There's plenty of time to hit the art supply store for better supplies once you get the rhythm of drawing.

When and Where to Draw

The answer to this is easy—draw anywhere and everywhere, any time of day, whenever you feel like it. That's the beauty of sketching. It's so simple and portable, there's no place it's 'not possible to sketch—except maybe on horseback at full gallop. (If you're drawing in church, I'd suggest taking the back pew!)

I try to draw some every day—it keeps hand/eye coordination in fighting trim. In the morning the light is more dramatic and my mind is fresher, but often when I've crashed for the evening, I jot a quick sketch from the image on my television set, or draw one of my cats as it waits for me to go for the can opener after the late news.

Draw what's out your window; the people in line at the bank; the first flowers in your garden; the shadows on the side of your house. Sketch when you're stuck in the doctor's waiting room or when you're waiting for your lunch date. Sketch the birds on your feeder. Draw in your local park or on a once-in-a-lifetime visit to Ireland or the Bahamas. Draw the mountains in the morning, or jot the details of a costume in a museum. Draw from paintings in a museum, as well, and learn the secrets of form and composition from the old masters as though you were an apprentice.

One of the nice things about draw-

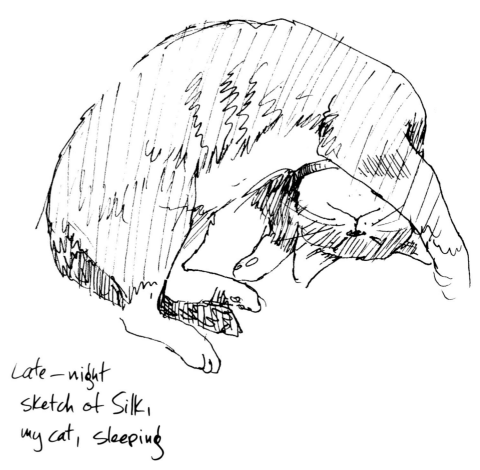

Late—night sketch of Silk, my cat, sleeping

ing is that it takes so little preparation. When you paint, you may need to stretch your canvas or watercolor paper, squeeze out your paints, do preliminary sketches, and transfer them to your painting surface. When you sketch—that's it. You pick up a pencil or pen and go to it. Your initial effort is also your finished product—or it can be. Of course, you can use any of your sketches as planning or research for future paintings, but I often find they stand on their own.

TIP

Try to find a bit of time each day to sketch, but keep it light. Don't make it yet another thing to squeeze into a busy schedule, or you won't do it. Think of it as letting yourself have some well-deserved fun rather than as performing an exercise.

First Materials to Buy

Here is a basic list you may want to get; we'll cover them in more detail ahead:

Pencil
Pen (fiber-tipped, ballpoint)
Paper (sketch pad)
Eraser
Pencil sharpener

Assuming you already have a yellow office pencil and a piece of scrap paper and have pressed them into service enough to know you want more, pay a visit to your local art supply or office supply store or check out one of the catalogs. Discount stores also carry just about everything you need at bargain prices. No matter *what* you buy to draw with it's still going to be less expensive than just about any other kind of art-making. Start out with a few graphite pencils—say a 4B, a 2B, and an HB, which will give you a very soft, blendable pencil, a somewhat harder one, and one to get fine details. You've spent less than five dollars, even if you've gone for the best artist's grade pencils. A fiber-tipped pen is about a dollar, as well. Choose one with a medium to fine point for best results. You can get water-soluble or indelible pens—why not get one of each!

An eraser should cost about a dollar, unless you're still using a no. 2 office pencil that comes equipped with a pink, rubber eraser. You may want both a kneaded-rubber eraser and a white, plastic one.

A 9″ × 12″ sketchbook should set you back about five dollars, for a total of just over ten dollars. (Go even simpler and buy the pad and one pencil—maybe a 2B—and you're on the way for just over five.) A small pen knife or plastic pencil sharpener completes your basic outfit and you're ready for anything.

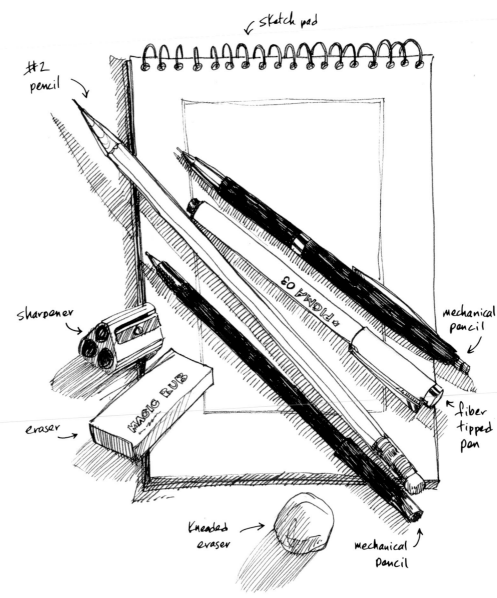

sketch pad

#2 pencil

sharpener

MAGIC RUB

eraser

Kneaded eraser

mechanical pencil

fiber tipped pen

mechanical pencil

TIP

For the most portable supplies, keep them small as well as simple. You can do nice sketches on a 3″ × 5″ pad; thumbnail sketches can be even smaller, and you can jot them in the margins of a book or magazine.

Beyond Basics—Papers

Most drawing and sketching papers have a bit of *tooth*. That means they have a subtle texture to catch and hold the pencil marks. Some, however, can be quite smooth, allowing you to get nice, sharp details. If you prefer, you can use a rougher-than-normal paper—like a watercolor paper—to emphasize a rugged texture in your drawing. Strathmore, Morilla, Pentalic and Aquabee are some good brands of drawing paper. Papers intended for use with ink are generally very smooth indeed. Pentalic makes a good one, as does Strathmore. The Strathmore Bristol Smooth is particularly nice.

You can buy sketchbooks made of newsprint or recycled paper, or you can go for 100 percent rag content, neutral pH—which means the paper will last for generations without cracking or yellowing as newsprint is likely to do. They're only a bit more

Hardbound Sketchbook (and Snail)

expensive, and I think they're worth it. I *like* my sketches; they're more alive than most of my paintings, and I want to be able to look at them years down the line.

Most sketchbooks are spiral bound, allowing you to lay them out flat and work on both sides of the paper, but some are glued and/or cloth bound along one edge. The advantage of these is that you can tear your drawings out without having the row of little round holes the spiral binding leaves; you can work all the way to the edges, all the way around, if you like.

You can also have paper bound into a hardbound book—my favorite form for taking into the field. The hardbound books cost more, of course, but they last forever and take any amount of abuse. (I've dropped

mine down a cliff and it didn't even get a dented corner.)

If you prefer, you can get a package of typing paper (or heavier weight) and use a clipboard for a drawing support. This is inexpensive (especially if you buy a package of five hundred sheets) and easy to work with. Again, you can get a very good quality of paper or something more for practice work.

I like to use a toned paper—tan, gray, gray-blue, perhaps—for sketching. It is available in loose sheets or in pads with a variety of shades (usually marked for use with pastels); some are made of recycled paper. I use a dark drawing tool like a pen or pencil, then come back in with a white pencil, chalk or opaque watercolor to pick out highlights. (We'll cover this technique in a bit.)

Toned Paper with Sepia Ink and Opaque White Paint

Drawing Marks

Degree of hardness or softness of your pencil lead makes a lot of difference in how it looks and handles.

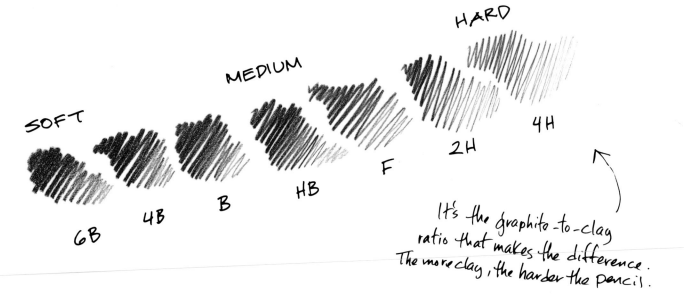

SOFT

MEDIUM

HARD

6B

4B

B

HB

F

2H

4H

It's the graphite-to-clay ratio that makes the difference. The more clay, the harder the pencil.

Soft leads make a nice, thunderous dark, but it's harder to get fine details and smearing is a problem. The really hard leads, on the other hand, only make light lines — but very, very precise ones.

THE KIND OF PAPER you choose makes a big difference, too. For most uses, you'll want paper with a smooth-to-medium "tooth" or texture

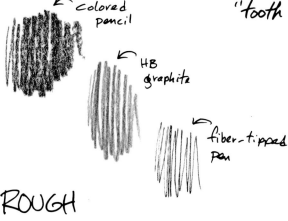

← Colored pencil

← HB graphite

← fiber-tipped pen

ROUGH

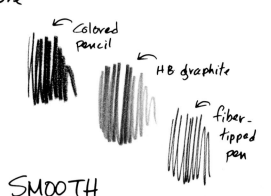

← Colored pencil

← HB graphite

← fiber-tipped pen

SMOOTH

Pencils

We talk about pencil "leads," but they're not made of that metal any more. Most of these are made by mixing clay and graphite and baking them together—the more clay in the mixture, the harder the pencil.

Some pencils, like the new Derwent Sketching Pencils, are soluble with water, so you can achieve soft halftones when you touch your drawing with a dampened brush. Still others are wax based. I like a black or dark gray Prismacolor colored pencil for sketching—this one is wax-based rather than graphite-based and not so likely to smear when I inadvertently rub my hand over my paper! You'll need to keep a sharpener with you, since it loses its point rather quickly. And like most artists' pencils, it doesn't come with an eraser. But this pencil is capable of a broad range of *values*. Value refers to the range of lights and darks you can use to suggest light and shadow and form.

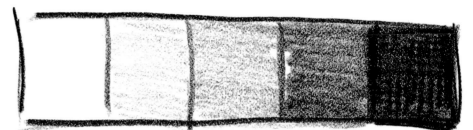

VALUE SCALE DONE WITH DARK GRAY PRISMACOLOR

When drawing you can either choose to go with lines alone, without tone, or use the full range of values.

Some are called mechanical pencils. These have refillable leads of various degrees of hardness, and they usually don't require a sharpener since the leads are so small in diameter—.5mm and .7mm. They often have a tiny eraser hidden under the cap; less-expensive models look a lot like the good old yellow office pencil and have a larger eraser on the tip.

A flat, sketcher's pencil lets you go for broader effects and areas of tone rather than line; try a 2B, which is reasonably soft. (General makes a good one.) These cost just over a dollar. You can also buy square graphite sticks that look like hard pastels, or woodless drawing pencils from Faber-Castell or Pentalic, which are just what they sound like—a big lead with a coating of enamel to keep your fingers clean. These cost about two dollars.

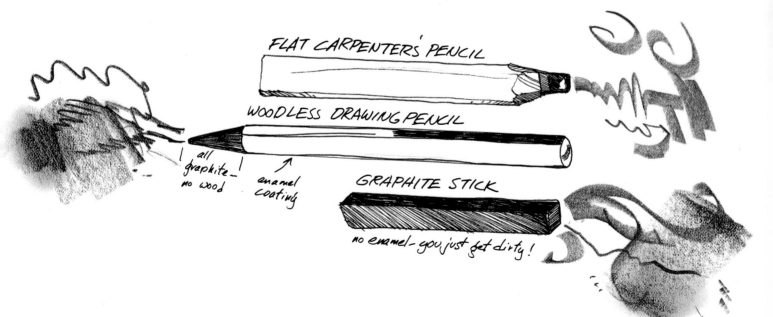

FLAT CARPENTER'S PENCIL

WOODLESS DRAWING PENCIL

all graphite— no wood

enamel coating

GRAPHITE STICK

no enamel—you just get dirty!

Pencil-Sharpening Tricks

For best results when sketching, don't use a mechanical or electric sharpener. Sharpen your pencil with a sharp knife, then make a chisel edge by rubbing the tip against a piece of paper or sandpaper.

Look at the lively effects you can get with a single tool!

If you're using a flat sketching or carpenter's pencil, sharpen it the same way — or cut notches in the edge for interesting linear effects, as shown.

un-notched

notched

Charcoal

Charcoal comes in several degrees of hardness, and it is easy to blend with a fingertip or a cardboard "stump" or tortillon (ask your art supply dealer to show you these). I love the effect of charcoal in other people's work, but it's far too messy for me. I end up with charcoal dust to my elbow!

Charcoal comes in chunks, in square compressed sticks, or in round sticks called vine charcoal, which can be broken to fit in a brass holder to keep your fingers clean. You can get charcoal pencils, too—just what it sounds like, charcoal encased in a wooden sheath or paper-wrapped so you can expose however much "lead" you want.

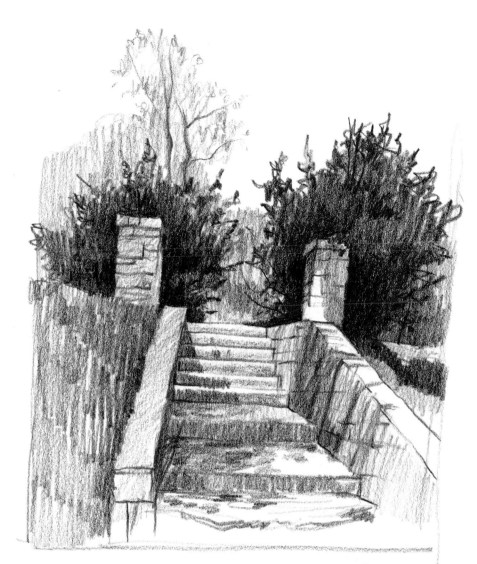

You can get a lovely range of lights and darks (and virtually every shade of gray in between) with charcoal. Here, a charcoal pencil was used to capture these old stone stairs.

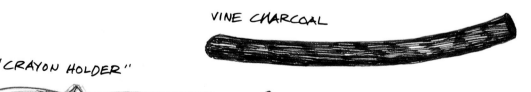

TORTILLON or "STUMP"

VINE CHARCOAL

"CRAYON HOLDER"

← pull to "sharpen"

CHARCOAL PENCIL (paper-wrapped)

Pen and Ink

These used to be two entirely different things, and they still can be. There's nothing to stop you from using a bottle of India ink (or a nice sepia or even a colored ink, if you prefer), and a dip pen. I still make my own quill pens from goose and turkey feathers. Try a bamboo pen, or one made of reed. And of course, there are literally dozens of metal nibs out there of all sizes and shapes that can give your sketches a lively, individual flavor.

But for portability's sake, you may want to stick to fiber-tipped pens (we used to call them felt-tips), a rolling ball, a ballpoint, or another inexpensive type of drawing pen that contains its own ink supply—either refillable or disposable. I usually use a Pentel pen or a Micron Pigma, which comes in a variety of nib sizes and is filled with indelible ink. Pentels, on the other hand, are water soluble, so I can wet the lines with clear water for soft tones.

Erasers

The old tan erasers you remember from grade school aren't worth much—they get crumbs all over your drawing. Try one of the new, white plastic ones, or a white, plastic stick of eraser in a mechanical holder like the ones made by Pentel (Clic Eraser). These won't damage your paper.

They leave a minimum of crumbs, and they lift almost any pencil mark satisfactorily.

A kneaded eraser works well to lift areas of tone or soft highlights from graphite or charcoal drawings—you almost use them to draw with. Before using a kneaded eraser, you have to pull it a bit like taffy a few times to activate it. It can absorb a lot of graphite and charcoal powder. Even after it looks quite dark, it will still work just as well.

But usually, you don't need an eraser at all: If you don't like the line you've put down, make a better one next to it, maybe darker or stronger to indicate the one you prefer. Bert Dodson, author of *Keys to Drawing*, calls this "restating" the lines, and says "Trial and error are *essential* in drawing . . . restatements demonstrate that drawing is a vital, changing process." There *are* no mistakes in sketching, just the process of getting from here to there, the process of making what you see on your paper more truly reflect what you see before you. I just let "incorrect" lines stay as is for a nice vibration.

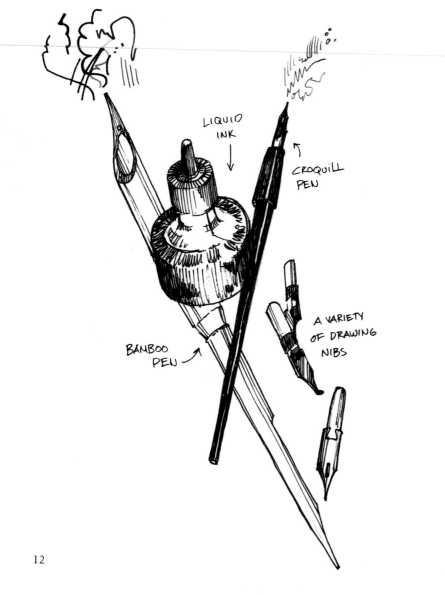

LIQUID INK

CROQUILL PEN

BAMBOO PEN

A VARIETY OF DRAWING NIBS

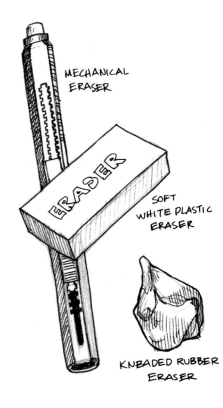

MECHANICAL ERASER

ERASER

SOFT WHITE PLASTIC ERASER

KNEADED RUBBER ERASER

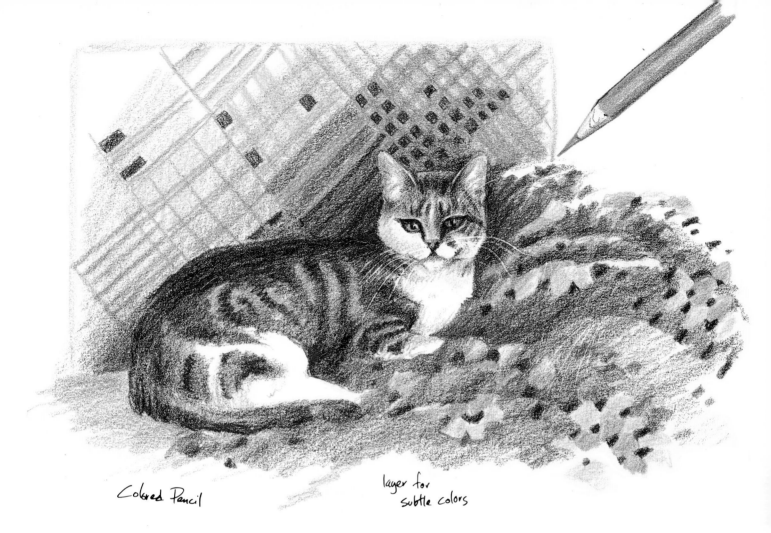

Colored Pencil

layer for subtle colors

Drawing Materials for Color

It's a colorful world, and just because you're drawing instead of painting doesn't mean you can't branch out into color. It's fun, and nearly as portable as drawing in black and white.

Good old Conté crayons are not what we think of as crayons if we're used to that yellow-and-green box of Crayolas we had as a kid. Contés have been around since the 1700s; they come in shades of black, ochre (light brownish yellow), white, bistre (brown), and sanguine (red-brown). They're fine for sketching, delicate and expressive.

But who's to say you shouldn't hop out to the discount store and buy a box of kids' crayons? I've seen some wonderfully subtle drawings done with these, and some bright, cheerful, fresh sketches as well. You can lay down a thick layer or use a linear effect, and the cost is as low as you'd ever wish.

Pastels are very popular for drawing in color, though the finished product is usually called a "pastel painting." You can buy hard or soft pastels in literally hundreds of shades. Both kinds can be easily blended with your finger. You can also get pastel pencils, which are soft, chalky pigment encased in wood.

Prismacolor—as the name suggests—makes much, much more than the black or dark gray pencils that I like to use for sketching. You can buy sets of twelve and more (*lots* more) colored pencils, or you can pick and choose the colors you prefer

Conté Crayon

Bistre

Sanguine Medicis

Sanguine XVIII

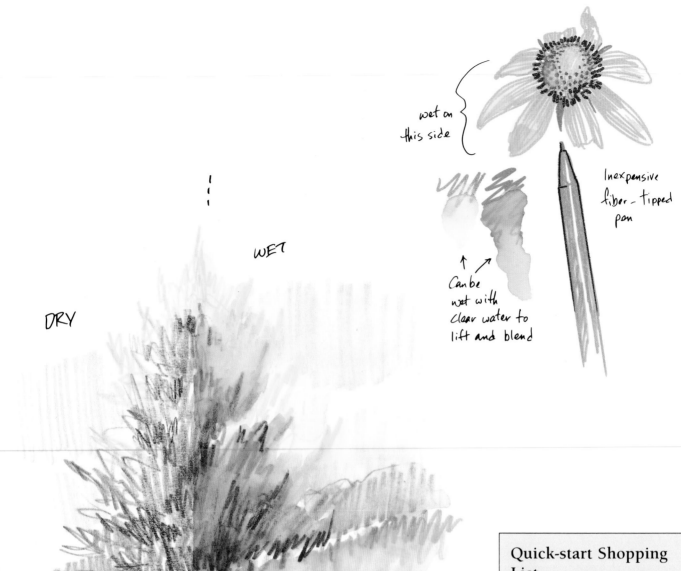

wet on
this side

Inexpensive
fiber - tipped
pen

Can be
wet with
clear water to
lift and blend

WET

DRY

draw
first,
then wet
with clear
water (I
wash my
brush out
often.)

Water - soluble
colored pencil

Quick-start Shopping List

Here's a list of basic drawing equipment you can take right now to your closest art supply source. Ask the clerk to help you assemble this starter kit, and you'll have everything you'll need to start drawing.

a 4B graphite pencil
a 2B graphite pencil
an HB graphite pencil
a water-soluble, fiber-tipped pen
 with a medium or fine point
an indelible, fiber-tipped pen
 with a medium or fine point
a kneaded-rubber eraser
a white, plastic eraser
a 9″ × 12″ sketchbook
a plastic pencil sharpener

individually, usually for about a dollar each. Design Spectracolor pencils are lovely, too, and won't build up.

Choose only a few colors, like the primaries (red, yellow and blue); you can get new colors by overlapping strokes. Or go for the entire spectrum and pick whatever color you want.

If you like a mixed-media effect, try *watercolor pencils*. These are colored pencils that dissolve with clear water applied with a brush; you can do your drawing first, then wet it for an effect very much like painting. Caran D'Ache and Derwent are two familiar names here, and again these come in sets and individually.

You can buy either of these in square stick form, as well, if you like that better than pencils for broader effects, or something that looks like a pencil but is all pure pigment.

Your local discount store may have a set of *fiber-tipped pens* in color. These are great for sketching, though they don't promise not to fade with time. I got my set of thirty-six colors for just over five dollars several years ago—for that kind of bargain-basement price, you don't expect permanence.

My favorite color-sketching medium is *watercolor*—the simplest, least expensive set meant for kids works fine for this, or invest in a small sketcher's set of watercolors. When I'm working in the field, I usually do a rough sketch in black, dark gray or sepia-colored pencil and lay in quick, splashy washes of watercolor. It's versatile, and you can add the color outdoors on the spot or later, back in your studio.

You can get a similar effect by drawing with indelible ink and adding a wash of color—it's sort of like creating your own coloring book.

You can even draw directly with watercolor: Use a small brush and draw just as though it were a pencil or crayon for a linear effect. If watercolor, with its tendency to run when wet, normally seems too difficult, try this method of drawing with the tip of a brush and only a little wet color. Let each dry between applications, and voilà— you've discovered how to control the medium while producing a nice, colorful sketch!

Watkins Mill Sunday
CA JOHNSON

Sketch using Warm Gray Dark Prismacolor and watercolor wash on watercolor paper cut to postcard size—4" X 6"

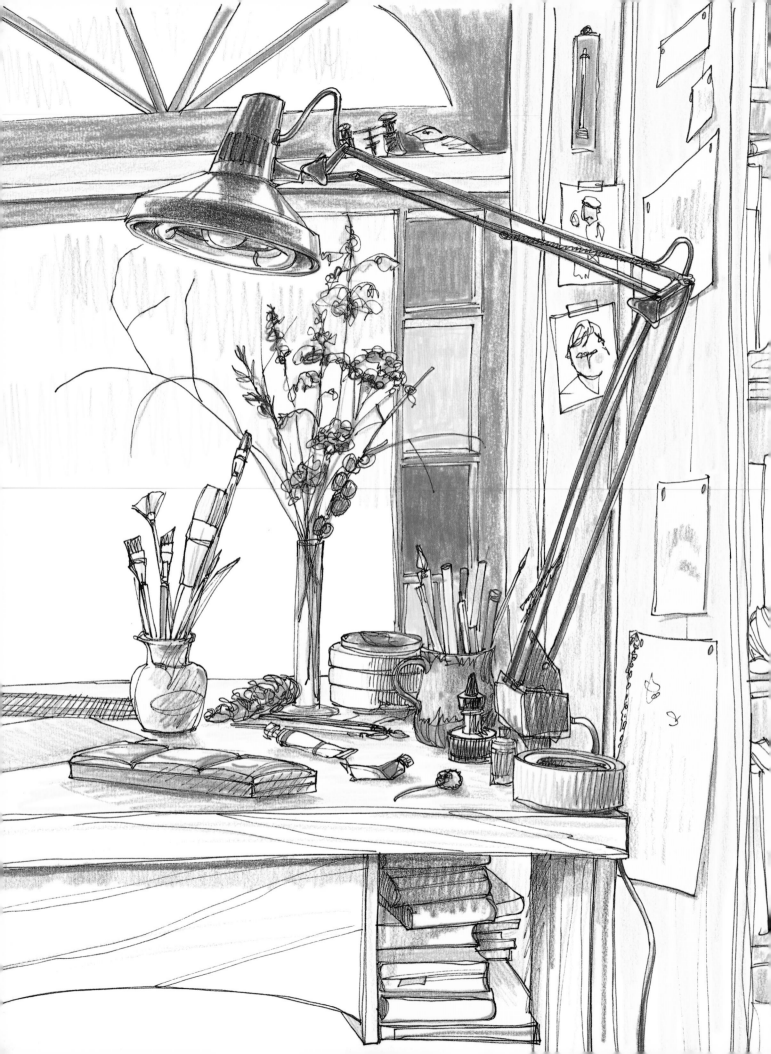

Chapter Two

EASY-TO-LEARN WAYS TO DRAW

D rawing *is* easy—look how much kindergartners enjoy it. They know that things don't have to look like photographs; they're more interested in the fun of drawing itself. I've heard too many people say "I know I *ought* to draw more," as though it were a chore (or something really awful, like giving up chocolate).

Get over *that* idea right away. Remember what it was like to own the possibilities in a new box of crayons? In fact, why not get out a box of good old Crayolas and recapture the joy of drawing?

The problem, sometimes, is that we have a preconceived set of ideas of how things look—and how to draw them. A tree is *not* a green lollipop on a brown stick. An eye is not shaped like a canoe, and certainly not from the side. We'll look at some of the ways of drawing that let you tap into your creative side and silence that critic that lives inside us all.

Most people can draw if they just give themselves a chance. In this chapter, we'll jump into some of the basic exercises to get you past the dread FOWP (Fear of White Paper), which we all experience occasionally, and let you rediscover what it's like to really see what you're looking at—and respond to it in fresh, individual ways that express what *you* want to say. We'll play with lines and tones and explore the capabilities of our tools. Throw away your rulers—you don't need them to make a lively, evocative drawing.

Hold It!

How you hold your pencil, crayon or pen is as personal as how you like your steak. Most people start out by holding their pencil like they do when they're writing—and if you're comfortable, there's nothing wrong with keeping it that way. It's often easier to capture details with the additional control this grip allows.

But artists often hold their pencils differently, as shown below, which allows you to use your whole arm and lets you lay in shading more easily. This gives great rhythm and sweep when you're working larger. Try out both for a variety of needs.

Fear-Conquering Exercises

As we said, everybody wants to do a good job when they draw. We worry about wasting paper, or time, or effort—as though any of these things were as important as the pleasure of creating. You *are* going to waste paper—or rather, you're going to throw a few sheets of it away. (It's hardly a waste if you've learned something new about your world and how you want to respond to it, is it?)

So, right up front, let's plan on tossing a few into the circular file. In fact, let's make some sheets just for that purpose! Take a sheet of inexpensive paper (this might be a good place to use that typing paper) and a no. 2 pencil.

Remedial Scribbling

Let your whole arm get into this. Make sweeping swoops and circular squiggles. Make waves and circles. Get some energy into it. Fill up the page; overlap lines or forms, if you want. Hold down the paper so it doesn't get away!

Abstract Doodling

Start in one corner of the sheet and make a long line down one side or across the top of your paper. Vary the pressure on your pencil. Keep your pencil point on the paper and make angular lines and diagonals until your paper is full.

Exploring Your Tools

This is one of the best ways to find out what your new tools will do. Make marks with each one. Lay down areas of tone. Make dots and lines.

Permanent marker

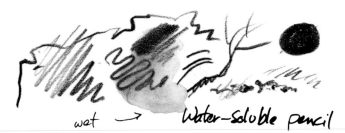

Dark Gray Prismacolor

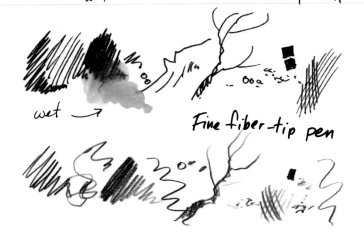

wet → Water-soluble pencil

wet → Fine fiber-tip pen

0.5 mm Mechanical pencil

Woodless drawing pencil

Flat sketching pencil

Pencils

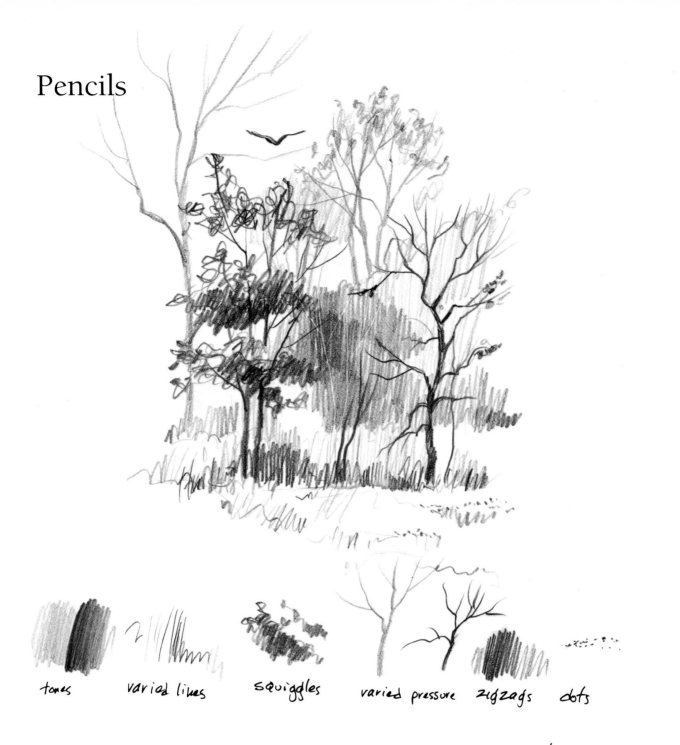

tones varied lines squiggles varied pressure zigzags dots

Try out your graphite pencils in a variety of ways — vary the pressure on your point, make squiggles or dots or zigzags and tones. Put them all together in a landscape sketch.

PENCILS... use different degrees of hardness and softness or simply vary the pressure, as above — a 0.7mm mechanical pencil with an HB lead.

Colored Pencils

The soft, waxy lead of a black Prismacolor colored pencil makes a wonderful variety of grays — at right are several methods for getting the halftones you want.

See how many tones you can get from a single pencil.

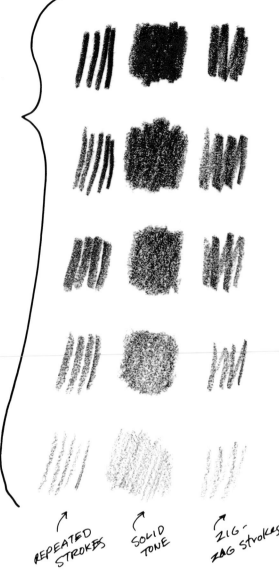

REPEATED STROKES SOLID TONE ZIG-ZAG STROKES

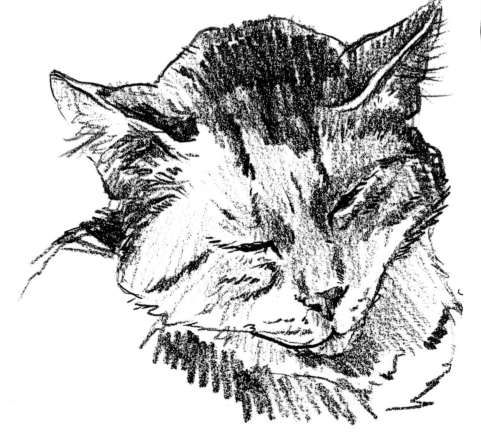

This cat drawing utilizes mostly repeated and zigzag strokes

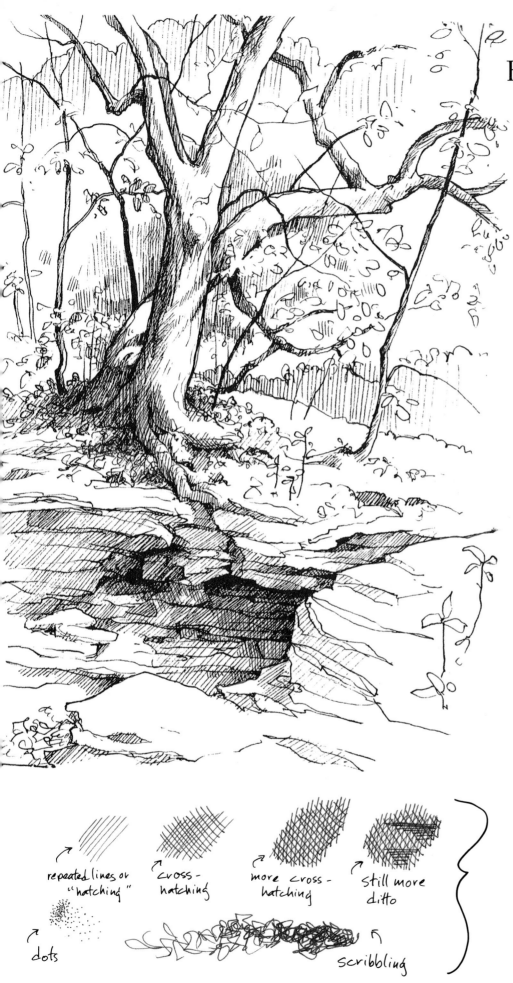

Fine-point Pens

Fine-point pens can be used to produce a range of visual grays by hatching or cross-hatching (as many times as you like), by scribbling, and by making dots.

See how many other ways you can suggest light and shadow with a fine-point pen.

↗ repeated lines or "hatching"

↗ cross-hatching

↗ more cross-hatching

↗ still more ditto

↗ dots

scribbling ↗

Choosing Your Medium

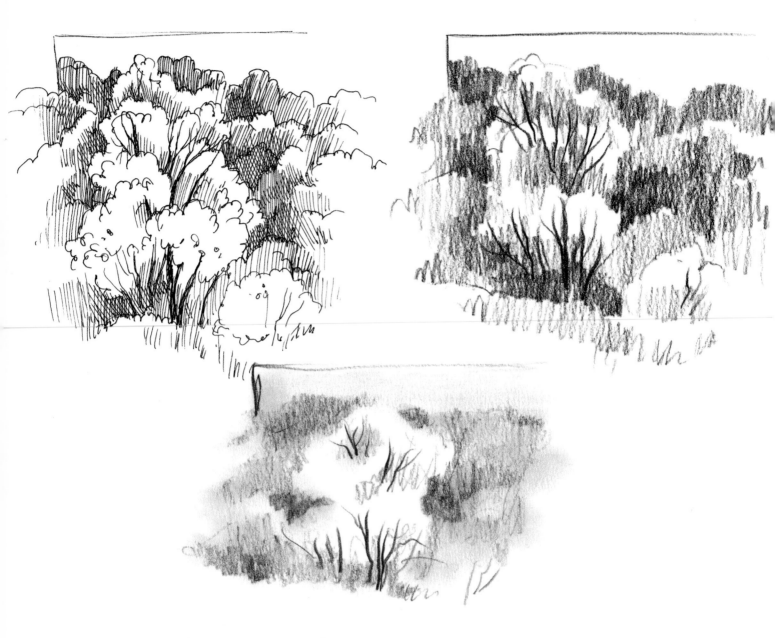

Choose your medium to match your subject or mood.

Here is a fine-point pen, a Prismacolor black colored pencil and a graphite pencil, all depicting the same subject, trees at the edge of the woods. Which do you prefer?

Combine Line and Wash

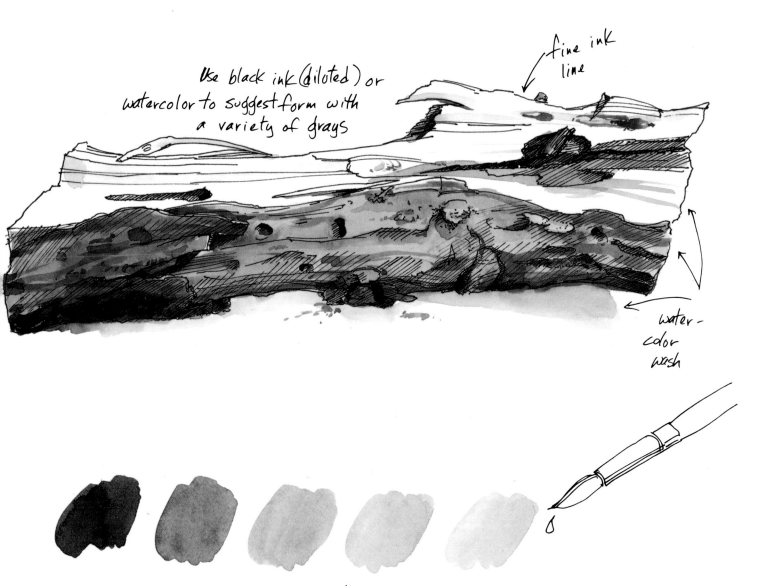

Use black ink (diluted) or watercolor to suggest form with a variety of grays

fine ink line

water-color wash

Add more and more clear water to an almost undiluted puddle of black or dark gray to get lighter and lighter tones. This can be extremely subtle — we kept the lightest light dark enough that it would still reproduce easily.

You Can Draw With a Brush, Too

Make yourself a simple pencil map to follow for shape and composition. Then, mix up a puddle of diluted ink or watercolor in shades of gray (or color). Dip your brush in, then wipe off excess liquid.

Spread hairs as shown if you like.

Let areas dry before adding new drybrush strokes

CATHY JOHNSON

or an Oriental brush pen

for a simpler effect, use a fiber-tipped brush pen – find one in the art supply store. You can get these in black or colors – work with almost solid tones with the side of the brush or get details with the tip.

tone

tip of brush

(BY THE TIME YOU FINISH EXPLORING ALL YOUR TOOLS, YOUR FEAR OF WHITE PAPER IS GONE!)

Basic Exercises—

5-second gesture sketch

Gesture Sketching

Gesture sketches—just going after the basic shape or direction or rhythm in thirty seconds or less—get you beyond the usual way of looking at things. You're moving so fast there's no *way* you can worry about details or chilly perfection. They're wonderful for getting down the shape of a bird before it flies, or the shape of your cat as it bathes, taking first one position then another. Anything, in fact, that moves quickly, can be captured in a gesture sketch—at least its essence if not every detail. You may want to use them for warming-up exercises at any time, no matter *how* long you've been drawing.

Try a couple of these. One might be a five-second gesture sketch of a tree or a clump of grass. Just try to catch the basic form, direction, texture or rhythm. Move fast!

Now, relax, slow down—do a thirty-second sketch. Again, look for the rhythm of your subject, not the details.

30-second gesture sketch

Contour Drawing

You may have done contour drawing in school—remember drawing something without looking down at your paper?—but never realized why it was such a great exercise. For one thing, you can't worry about what your drawing will look like, so you can't get paralyzed by self-consciousness. After all, you're not even looking at your paper. You *are* really paying attention to your subject rather than your self-conscious attempt to capture it on paper—maybe for the first time.

Find something to draw that interests you—a beat-up cowboy boot, a match holder or a flower. Now, turn your paper somewhat away so you can't see both at one time.

Pretend your pencil point is an ant crawling along the contour of your subject as you trace it onto your paper. Draw into the form if you want to try some of the detail inside the contour; just because it's called "contour drawing" doesn't mean you have to stick to the *outside* contours. Keep the point on your paper; if you lift it you'll get lost. (That's okay, too—this is just an exercise, after all.) You may wander off the edge of the paper; I can practically guarantee that you won't end up where you began. What you will get is a drawing that has somehow captured the truth about your subject, no matter how odd it may look at first glance.

Now, look at your subject occasionally. Not much—just enough to make sure your lines are on track. This is how most successful artists work. It's when we become too enthralled with what's on our paper (or too worried about it) that we lose track of the excitement that attracted us to our subject in the first place.

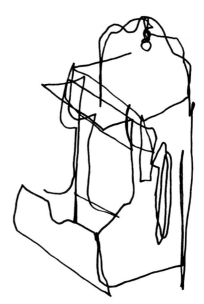

pure contour
drawing

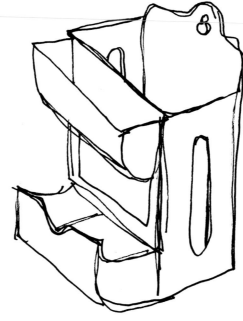

modified contour
drawing

Memory Drawing

This exercise trains you to remember what you see—at least enough to be able to get it down on paper. It's great for when you see a strange bird (but it flies), for sketching a landscape through a car window (not while you're the driver!), or any time you want to capture a fleeting image. Our pets and kids are always mobile: Memory drawing will help you to sketch what you saw long after Butch has run off with your sock or little Jean Ann has jumped off the swing and gone on to other things. Obviously, this pencil sharpener wasn't going anyplace, but if I had seen it in an antique store, I could have committed its image to paper long after I went home.

Give yourself two to five minutes to look—really *look*—at your subject (assuming you have that long). Ask yourself questions that will help fix details in your mind. What shape is it? Does that bird have an eye-stripe? What color was that dog, and how was it marked? Did it have long ears or short? How did the arm look when her body was turned away? These verbal questions will help kick-start your non-verbal, creative response.

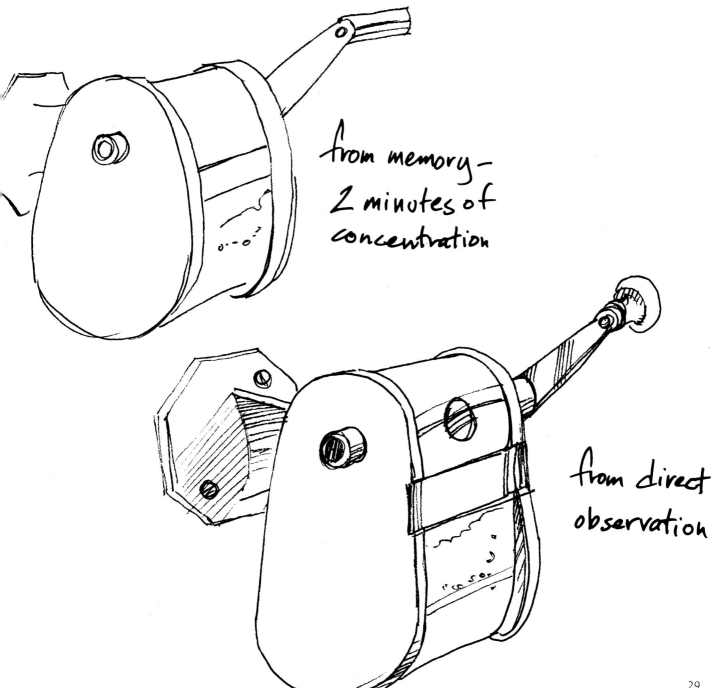

from memory—
2 minutes of
concentration

from direct
observation

More Basic Techniques—

fiber tipped pen colored pencil bamboo pen + ink steel nib + ink

Exploring Line

Line drawing is pretty much what it sounds like—using lines to capture your subject. There's no shading, no lights and darks, no sense of form. If this sounds sterile or flat, trust me, it's not. It's lovely, pure and clean.

Try out your various tools to see what kind of lines they'll make—uniform or nicely diverse. Vary the pressure on your pencil point—lift it almost off the paper, then push it down emphatically. Use the edge, too.

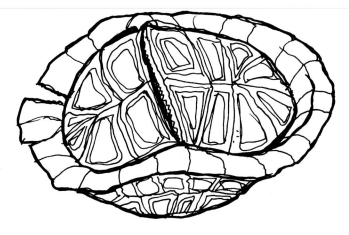

Project:

Now try a drawing using just line. Choose something relatively simple, like this upside-down turtle shell. Vary line weight for interest; I used a 01 and 05 Micron Pigma pens.

If you like, let heavier lines suggest those parts of your drawing that are closest to you and lighter lines suggest distance.

Use Line to Suggest Direction or Planes

let your pencil or pen-point follow the form of your subject to suggest angles or roundness

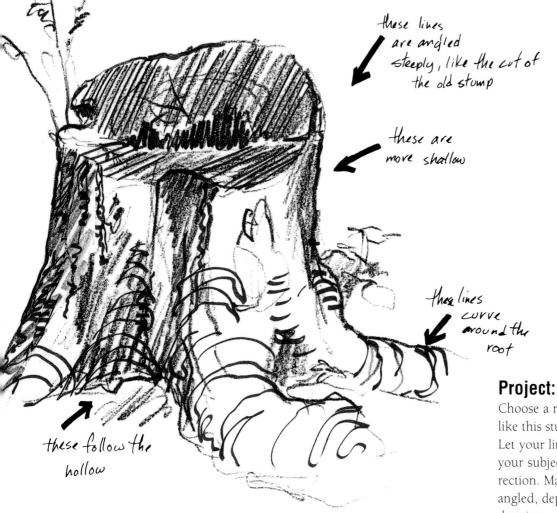

these lines are angled steeply, like the cut of the old stump

these are more shallow

these lines curve around the root

these follow the hollow

Project:

Choose a relatively simple subject like this stump, or a rock or boulder. Let your lines follow the shape of your subject, or let them suggest direction. Make them rounded or angled, depending on what you're drawing.

Blocking In

This is a classic technique that lets you rough in or block in the basic shape of your subject. Naturally, the lines you'd use would be very light; these are heavier so they'd reproduce well.

Project:

Find a simple but somewhat challenging shape and define it with rough, light lines. (Keep them faint enough that you could erase them easily if you don't like their placement.) When you're happy with the overall shape, refine your drawing, smoothing lines and adding details.

← Use quick, rough lines to locate and suggest the basic shape of your subject (Keep them lighter than these.)

Now, refine the shape, smoothing and elaborating on lines and adding shading →

Shading

Up till now, we've been working mostly with line in our basic exercises—even when you used crosshatching, it was still lines. You can use shading to suggest form and roundness and the effects of light and dark—it can be rough and sketchy or very smooth and almost photographic. Try the flat side of your pencil point, or one of the flat sketcher's pencils. Draw with a graphite stick. Use a color stick, if you like.

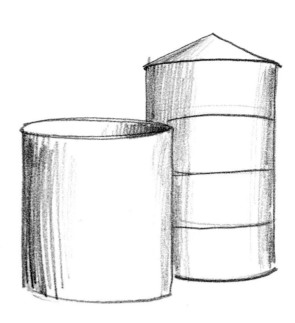

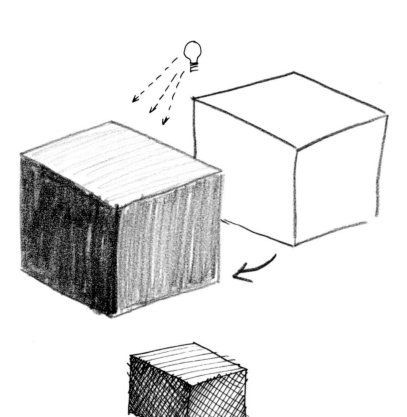

Project: Shading Trick #1

Make a cylinder and add tone to suggest roundness—more on one side, less on the other. Remember to fade into a lighter shade as you go around the form—and remember that when the tubular shape is hollow, the shading often goes the other direction as in the large, squat cylinder. Use this trick to suggest silos, drinking glasses, coffee mugs, even cone-shaped objects.

Project: Shading Trick #2

Draw a simple, box-like form to make a cube. Look to see where the shadows are darkest to suggest the direction the light is coming from. Now add the shadows, both form and cast. (Notice you can get similar effects by hatching and crosshatching lines.)

Blending

If you like a smoother, more tonal effect, try BLENDING your pencil lines, then LIFTING with a kneaded eraser.

Project:

Make a nice, round form—like this mug. Now, lay in tone as shown and blend smoothly with your fingertip or tortillon. You can lift tone back with an eraser, if you want, to suggest highlights on a graphite or charcoal drawing. (It doesn't work as well with wax-based colored pencils and doesn't work at all, with ink.)

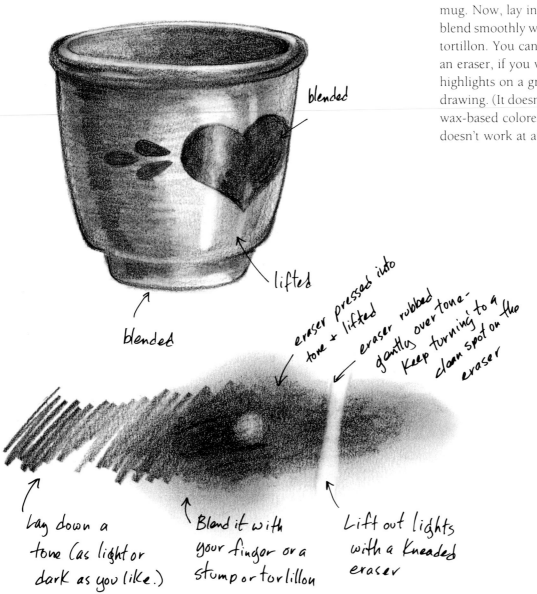

blended

lifted

blended

eraser pressed into tone + lifted

eraser rubbed gently over tone- keep turning to a clean spot on the eraser

Lay down a tone (as light or dark as you like.)

Blend it with your finger or a stump or tortillon

Lift out lights with a kneaded eraser

Drawing Squares, Rectangles, Circles and Ovals

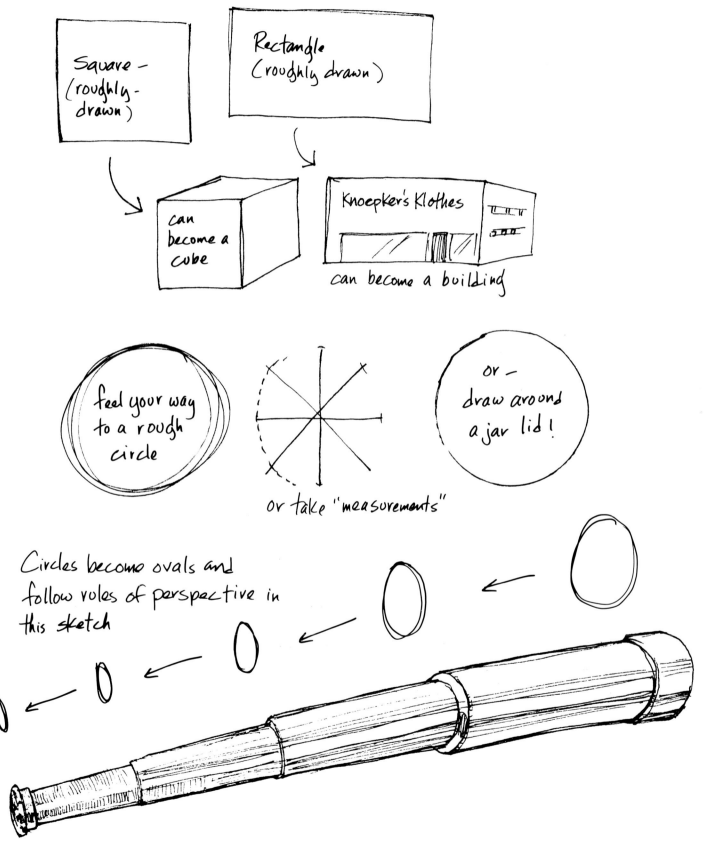

Square - (roughly- drawn)

Rectangle (roughly drawn)

can become a cube

Knoepker's Klothes

can become a building

feel your way to a rough circle

or take "measurements"

or - draw around a jar lid!

Circles become ovals and follow rules of perspective in this sketch

Drawing Ellipses

When you're sketching or drawing it's usually not necessary to make _perfect_ ovals — you're not designing jet engine parts, after all!

A freehand oval is usually just fine (look for negative shapes around it and draw _them_) or use our quick trick at right.

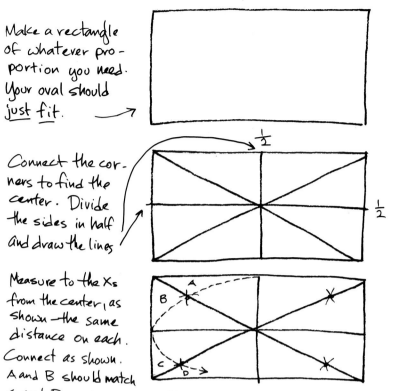

Make a rectangle of whatever pro- portion you need. Your oval should _just fit_. →

Connect the cor- ners to find the center. Divide the sides in half and draw the lines

$\frac{1}{2}$

$\frac{1}{2}$

Measure to the Xs from the center, as shown — the same distance on each. Connect as shown. A and B should match C and D and on around the oval.

★ Note that the ends of an oval are _always_ curved, not pointed.

A

B

C

D

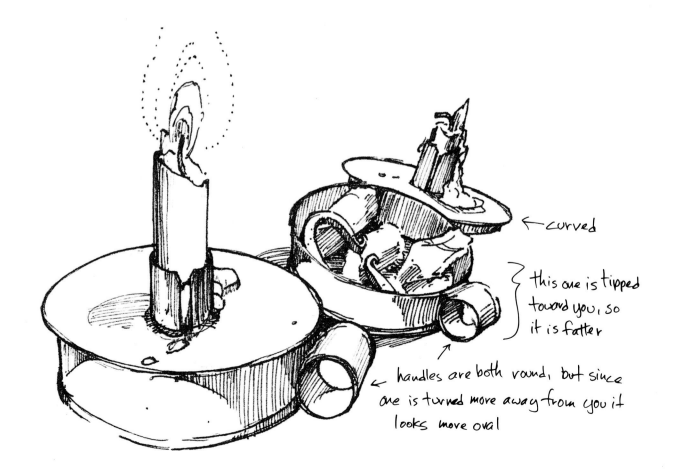

← curved

} this one is tipped toward you, so it is fatter

handles are both round, but since one is turned more away from you it looks more oval

Drawing Cylinders

Not all cylinders are perfectly round...

this lighthouse has a faceted top that nonetheless is like a tubular shape. Watch where shadows help reinforce a sense of form. The shape still follows the rules of perspective, too — as you look up at the underside of the roof, the "oval" form there appears deeper.

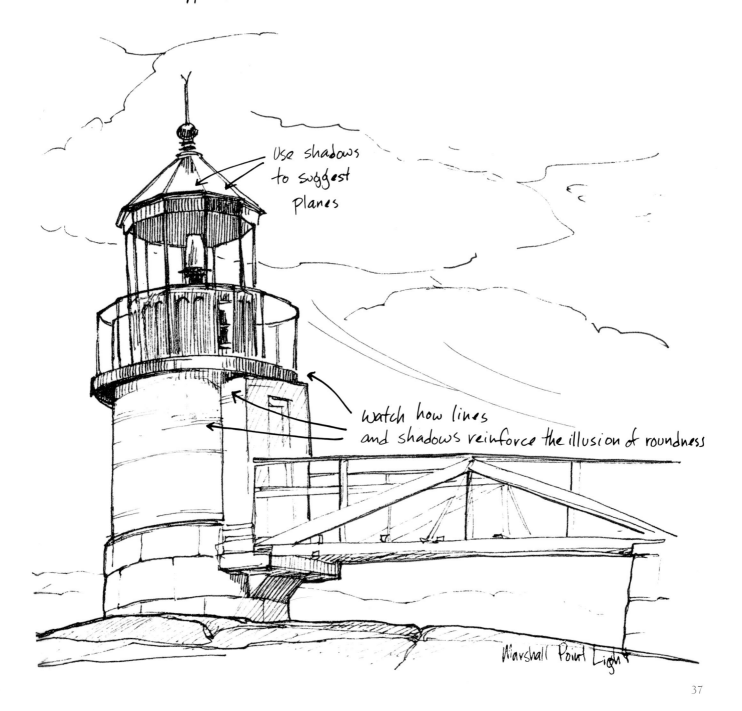

Use shadows to suggest planes

Watch how lines and shadows reinforce the illusion of roundness

Marshall Point Light

Using Ovals and Circles

Project:
Look for a simple shape that will fit comfortably in an oval, circle or square. My fat cat was the perfect choice. Draw the rough oval shape first, then a smaller one to suggest the head. Now, draw the details that bring your subject to life. Combine ovals, circles, cylinders or whatever, if you need to.

Using a Visual Measuring Device

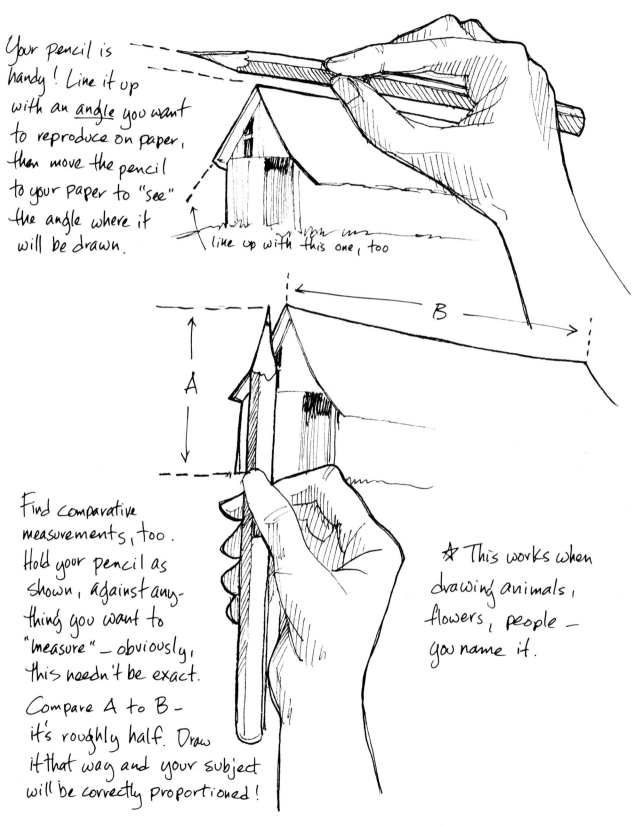

Your pencil is handy! Line it up with an <u>angle</u> you want to reproduce on paper, then move the pencil to your paper to "see" the angle where it will be drawn.

line up with this one, too

A

B

Find comparative measurements, too. Hold your pencil as shown, against anything you want to "measure" — obviously, this needn't be exact.

Compare A to B — it's roughly half. Draw it that way and your subject will be correctly proportioned!

☆ This works when drawing animals, flowers, people — you name it.

Sketching—

Sketching is really the same as drawing — only, generally, quicker and looser. You can sketch for a variety of reasons or purposes — THUMBNAIL SKETCHES, as at right, help you to plan a composition or range of values. These can be quite small, as their name suggests.

Sketches can also be used to capture a scene, take color notes, plan what to include in a painting — or just to relax. Sketch your pets, your Children, birds at the feeder, a once-in-a-lifetime trip, a planned sewing project — whatever you like.

rough detail

rocks are cool gray-blue

background hazy blue-green

light here

light, bright green

creek reflects sky — brownish in shadow

somewhat more subdued

Try a New Outlook

Sometimes a new perspective or a different angle are all you need to break free from symbolic thinking. A cat is <u>not</u> two circles, two triangles and a line, but a graceful, living, breathing entity.

Your subject doesn't have to be alive for this technique to work, of course. Hold a vase, a footstool (or a photo) upside down and see how much easier it is to draw what you <u>see</u>, not what you <u>know</u>.

features foreshortened, one ear not visible at all

feet and legs in unusual positions — not at the "four corners"

Draw Negative*
Shapes

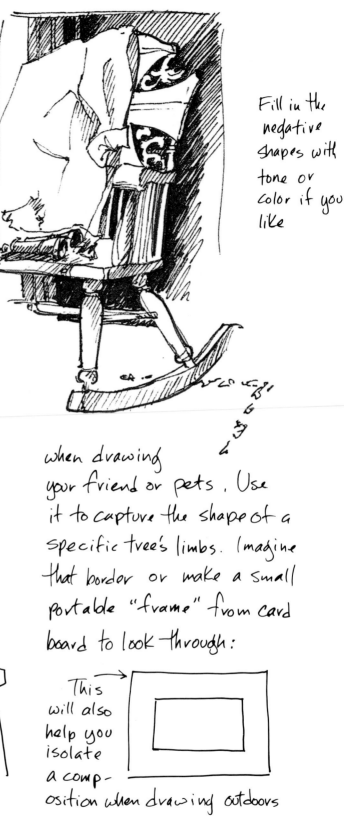

To help you to
see what's going on – draw
a rough border to "contain"
those shapes and help you
compare them to an edge.

Use this when drawing
inanimate objects or ...

Fill in the
negative
shapes with
tone or
color if you
like

when drawing
your friend or pets. Use
it to capture the shape of a
specific tree's limbs. Imagine
that border or make a small
portable "frame" from card
board to look through:

This
will also
help you
isolate
a comp-
osition when drawing outdoors

* Negative, in this context, just means those usually ignored spaces that surround
your subject

Practice, Practice, Practice

Project:
Take a few minutes each day—or several times a week—to draw something. Easy or hard, it doesn't matter: It's the practice that counts.

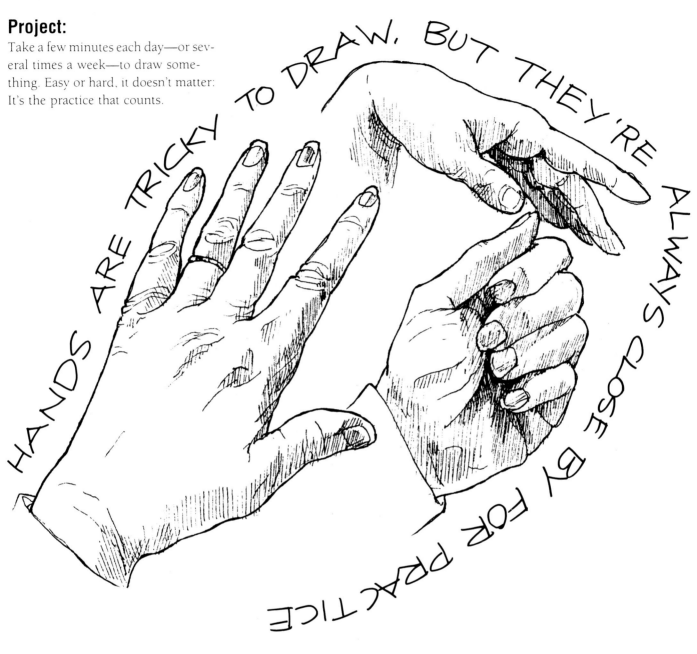

HANDS ARE TRICKY TO DRAW, BUT THEY'RE ALWAYS CLOSE BY FOR PRACTICE

Keep in practice — the more you draw, the better you'll be at it. Pick something challenging + interesting, but something you can control (like your hand.) Remember negative shapes and contour drawing. Keep your hand in — pun intended!

There Are No Rules

Except, of course, that you should enjoy what you're doing. If your drawing isn't technically correct, don't worry about it. Restate the line or just leave it. Often the point is taking time to draw — results are mere by-products.

Don't feel you have to finish everything with an equal amount of detail...

Stop whenever you want to. You can come back later, or you may discover your drawing is more interesting if you leave something to the imagination

Keeping a Field Journal

can be a lot of fun as well as a learning experience. Record the actions of birds or mammals (draw them from as many positions as possible), and make notes about what you observe. Add the date (and time of day, if you like) plus a note or two about the weather.

Draw wildflowers, turtles, butterflies or whatever catches your eye. Check what you've observed against the facts in a field guide. A habitat sketch is nice, too, and if you happen to see something totally unrelated to the drawings on your page (like the great blue heron sighting, below), add it anyway. It preserves the flavor of the day.

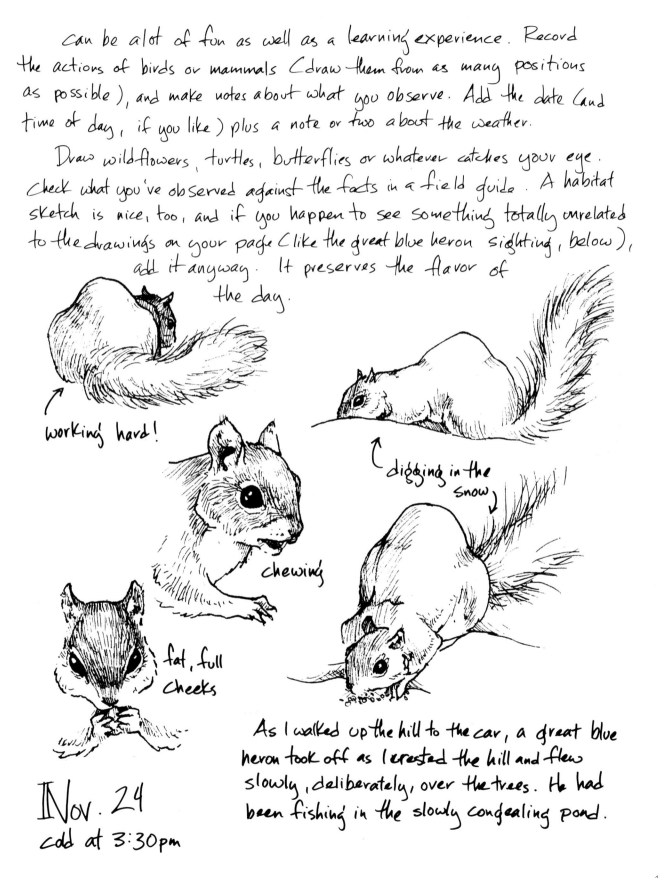

working hard!

chewing

digging in the snow

fat, full cheeks

Nov. 24
cold at 3:30pm

As I walked up the hill to the car, a great blue heron took off as I crested the hill and flew slowly, deliberately, over the trees. He had been fishing in the slowly congealing pond.

Keeping a Field Journal

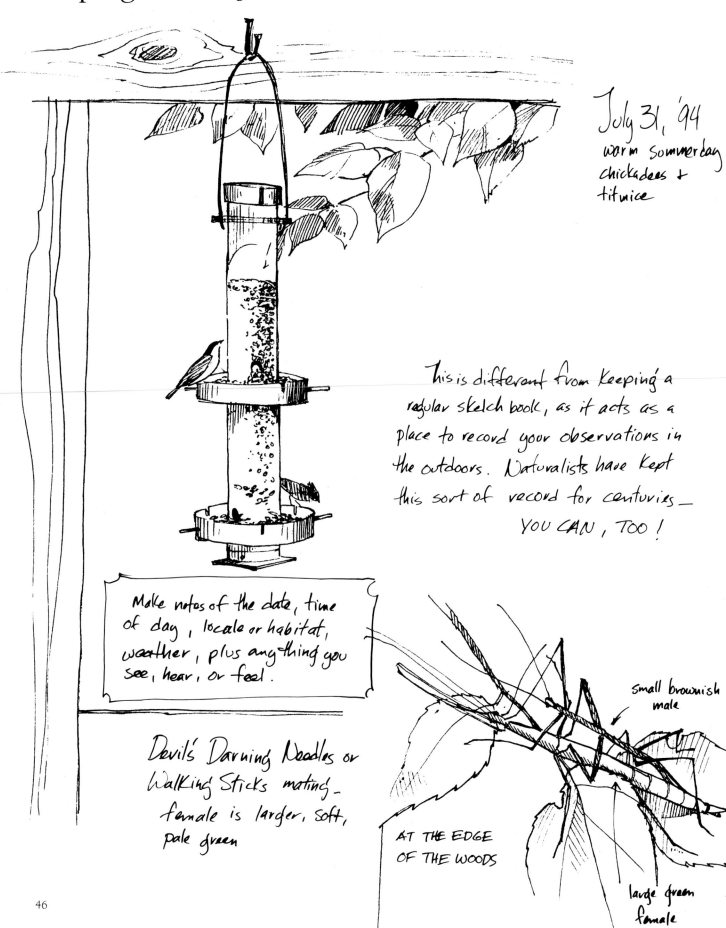

July 31, '94
warm summer day
chickadees +
titmice

This is different from keeping a
regular sketch book, as it acts as a
place to record your observations in
the outdoors. Naturalists have kept
this sort of record for centuries—
YOU CAN, TOO!

Make notes of the date, time
of day, locale or habitat,
weather, plus anything you
see, hear, or feel.

Devil's Darning Needles or
Walking Sticks mating—
female is larger, soft,
pale green

small brownish
male

AT THE EDGE
OF THE WOODS

large green
female

Keeping a Field Journal

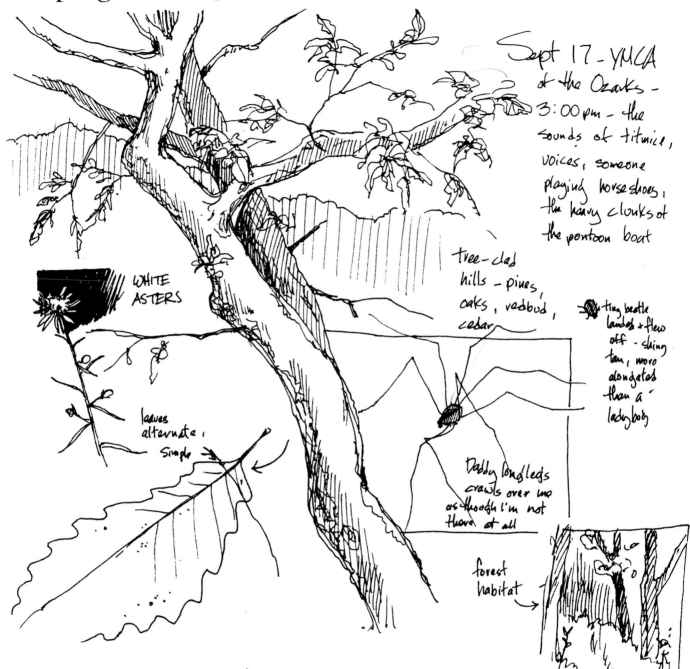

Sept 17 - YMCA of the Ozarks - 3:00 pm - the sounds of titmice, voices, someone playing horseshoes, the heavy clunks of the pontoon boat

tree-clad hills - pines, oaks, redbud, cedar

tiny beetle lands & flew off - shiny tan, more elongated than a ladybug

WHITE ASTERS

leaves alternate, simple

Daddy longlegs crawls over me as though I'm not there at all

forest habitat

This is a page from my own field journal. On it I included everything I noticed around me, including the Daddy Longlegs that ran across my knees. The details, both drawn and written, serve to bring back the day in my memory, as well as telling me a bit about this Ozark ecosystem.

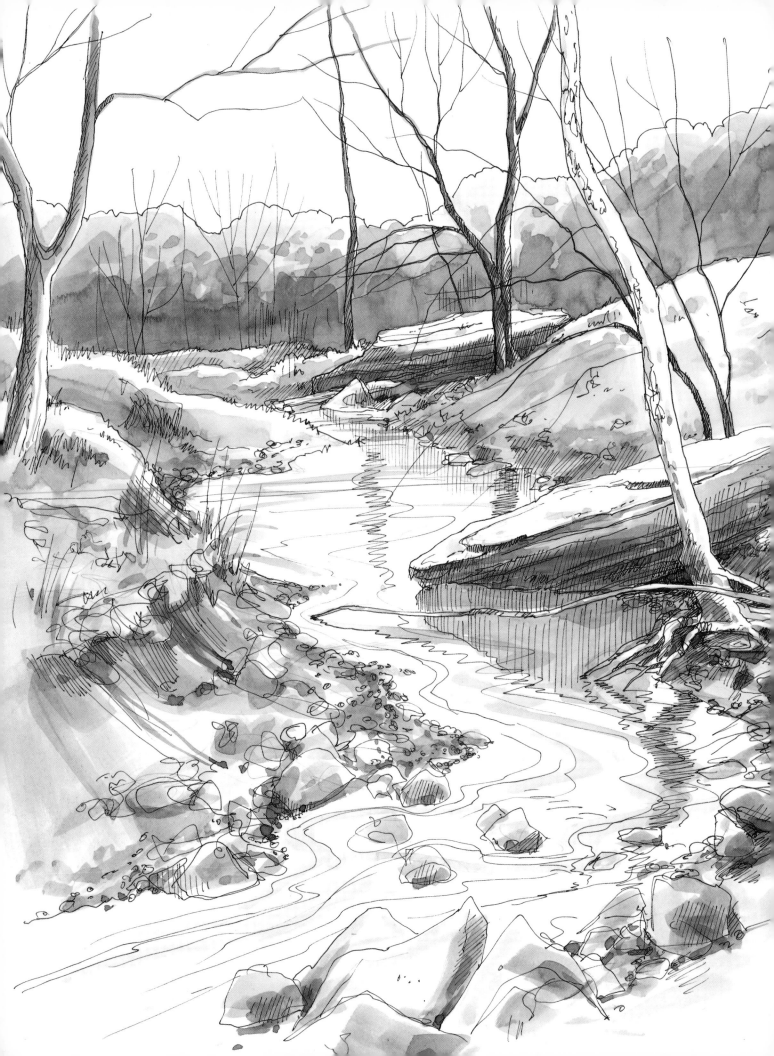

Chapter 3

Get Drawing

Now that you've tried out some of the basic exercises and gotten familiar with your tools (and probably settled on two or three you're most comfortable with), you're ready to draw specific common things. We'll do more with ovals and circles (which can be used for literally dozens of things) as well as getting into more recognizable objects—glass bottles, fruit, flowers, trees, grasses, water, and even people in landscape. (It isn't necessary to be a figure painter as accomplished as Rembrandt—we're just going to suggest people with a bit of visual shorthand, to give your drawings a bit of life or a sense of scale.)

Then, let's branch out and have some fun with color. We won't worry about color theory and other complex matters. Life's full of rainbow hues, and although a black ink line can be very expressive. There's nothing like the color of a flower to make you glad you're alive. Imagine an autumn scene without the riot of color that brings the season to life!

Still-life drawings are enjoyable; they don't have to be stiff, sterile exercises. Include elements that are particularly yours. Draw things you *like*. A bowl of fruit and a bottle of wine are fine, and you should know how to draw them, too—but it's best to include your *favorite* things. Use the bowl your grandma left you, and include a little figurine you picked up in Chinatown. Or if you're like me and drag home every interesting rock or fossil you see, include them in your drawings. A friend who teaches drawing to kids says one of her favorites of her student's drawings contained a broccoli spear and a spotted salamander! Make your still lifes *personal and meaningful*, and you'll have a lot more fun.

Oval Shapes

Oval shapes are useful in a wide variety of situations, but especially in still life drawings. It's not necessary to make a _perfect_ oval

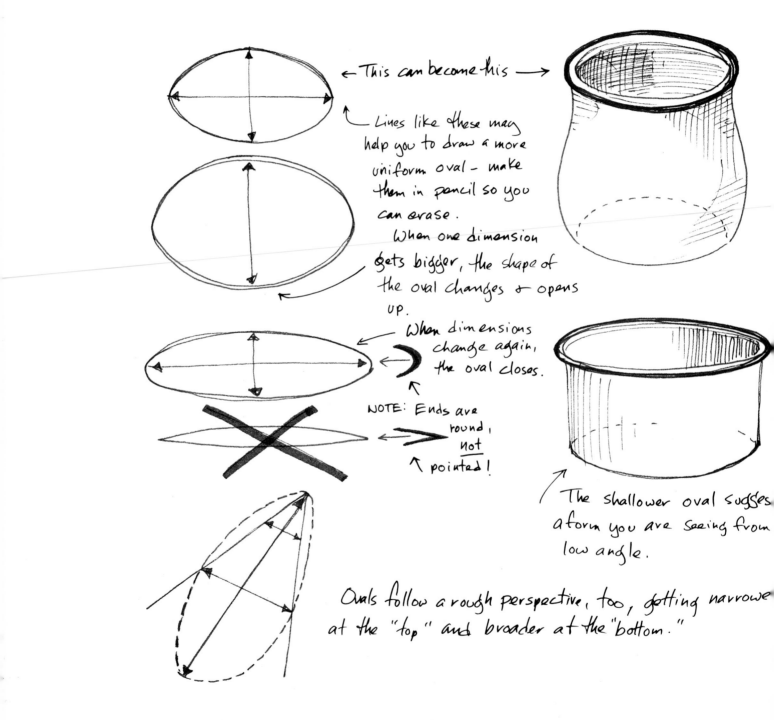

← This can become this →

Lines like these may help you to draw a more uniform oval — make them in pencil so you can erase.

When one dimension gets bigger, the shape of the oval changes & opens up.

When dimensions change again, the oval closes.

NOTE: Ends are round, _not_ pointed!

The shallower oval sugges a form you are seeing from low angle.

Ovals follow a rough perspective, too, getting narrowe at the "top" and broader at the "bottom."

Ovals

Ovals change shape a great deal depending on their relationship to your eye. Look across the top of one and it's almost FLAT.

Look down on one and it becomes much more round.

And in fact as this drawing suggests, round objects like this teapot and trivet only <u>look</u> oval because of the angle we view them from.

Try looking directly down on a teapot to see what I mean.

Project:

Find a simple, rounded shape that becomes an oval when you look at it at a variety of angles. Draw it from directly above, from just above eye level, and at eye level to see how the shape seems to change in the same object.

Circles

These forms can be oranges...

A simple tool for drawing reasonably accurate circles is to make intersecting lines like these, all the same length. A gently curving line to connect them becomes a circle!

← Plums...

Grapes...

(or turtle shells, bird's nests, walnuts - __anything__ round)

Shadows and highlights suggest visual roundness and dimension

CIRCLES are just as useful as ovals (in fact many ovals are just circles viewed from ground level instead of a bird's eye view.)

This ripe, shiny tomato is roughly round.

Vase Shapes

They can be very simple, like those at left, or shaped like fancy figurines.

All those at left were viewed from the same eye level.

tall & thin wider, more open short, round

If you need to make both sides similar — or even (shudder!) exactly alike, use lines like those at left to help you draw more accurately — or to see where you went wrong. (Ooops.)

Some people draw half their vase, then fold down the middle & trace the other side to make sure it matches →

fold flat

trace here

original shape

Glass Bottles

Look for the shapes made by the shine of light on the glass. Don't just automatically use a cartoon-drawing highlight like that at left. That really only works if you're showing the reflection of a double-hung window with crossbars! ⟶

"Map" the shapes of light & dark. Some can even show through the glass to make it appear transparent.

The water tumbler at right is a bit more complex, but it's the same idea. (Except, of course, it's 2/3 full!) Draw the basic, overall shape (a cylinder, in this case), then map the shapes you see. Use contrasts of light and dark for a "glassy" look.

Drawing Flowers With Geometric Shapes

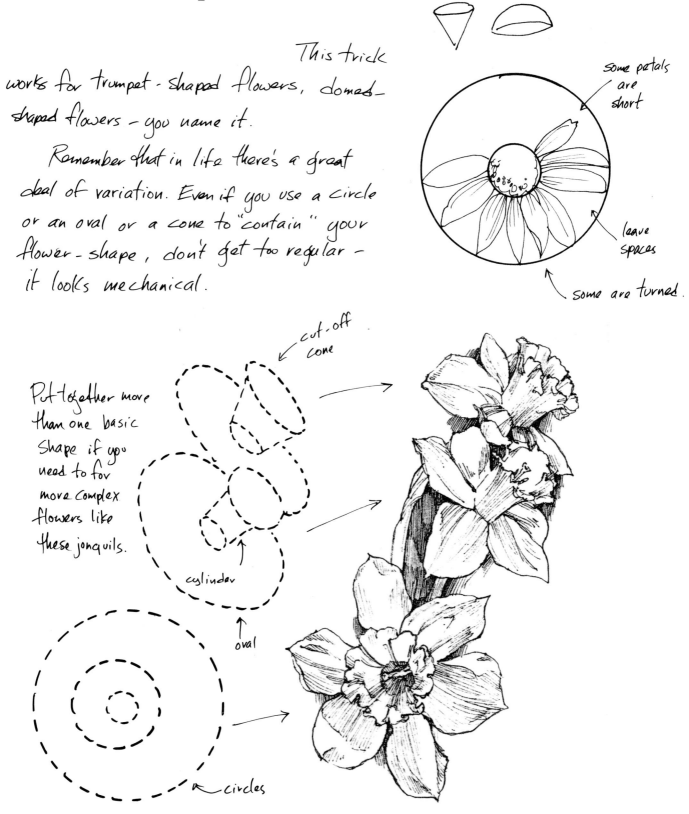

This trick works for trumpet-shaped flowers, domed-shaped flowers — you name it.

Remember that in life there's a great deal of variation. Even if you use a circle or an oval or a cone to "contain" your flower-shape, don't get too regular — it looks mechanical.

some petals are short

leave spaces

some are turned.

cut-off cone

Put together more than one basic shape if you need to for more complex flowers like these jonquils.

cylinder

oval

circles

Flowers

Project:

Pick a simple flower (or small bouquet of them). See how many different ways you can draw that same flower. Use the basic drawing techniques we talked about in the last chapter.

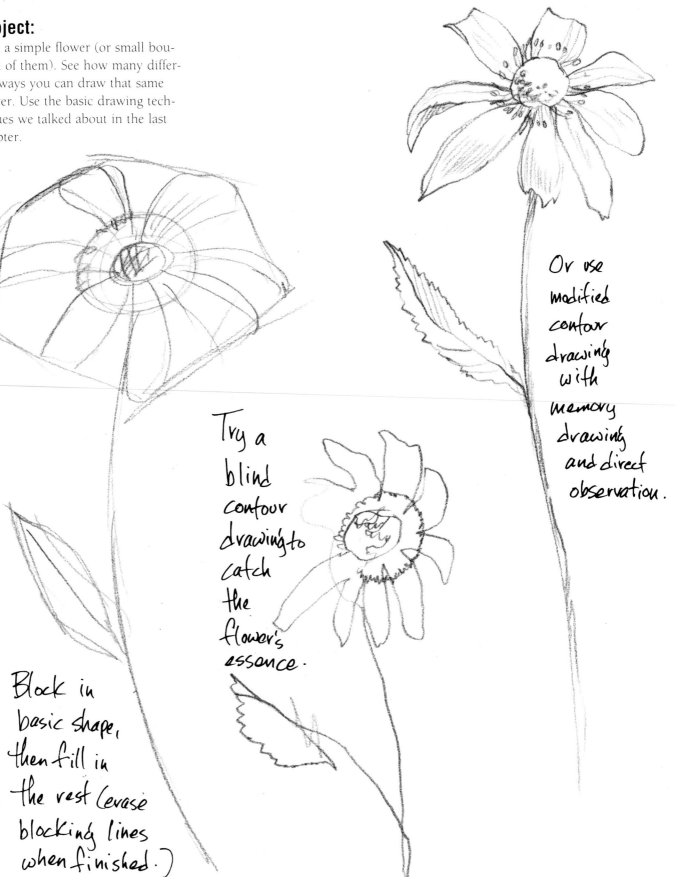

Or use modified contour drawing with memory drawing and direct observation.

Try a blind contour drawing to catch the flower's essence.

Block in basic shape, then fill in the rest (erase blocking lines when finished.)

Drawing Fruit

Drawing fruit is just like any other subject—

Start by capturing the basic form (by whatever method is most comfortable) then add shading and details.

BASIC BANANA

BANANA WITH AN ATTITUDE

scratch marks

"banana dots"

shadow

Don't feel that just because an apple fits - roughly - in a nice round circle that it has to be boring to draw. This one is fresh from the tree, complete with leaves and a tiny, tiny ant.

(See "Circles" for other fruits)

Still Lifes

Still lifes can be made of of decidedly non-traditional subjects, like this collection of stuffed animals. The same principles apply.

* You can use geometric forms to sketch in basic shapes, then add detail
* Shading (crosshatching, in this case) suggests depth and form
* Overlapping shapes create the illusion of depth, too.

fit shapes into geometric forms

overlapping forms

Project:

Find a variety of objects you're fond of—not the typical vase and flowers stuff. Practice capturing the forms in ovals and rounds, then add details. Try this project in pen-and-ink, if you like, or pencil, colored pencil—whatever.

Still Lifes

Still Lifes can be composed of a number of forms—ovals, cones, tubes, etc. They can be partially completed vignettes, like the one below.

Draw in the rough shapes, then add details of texture or a fancy edge.

egg-shape

oval

cylinder or tube

Drapery

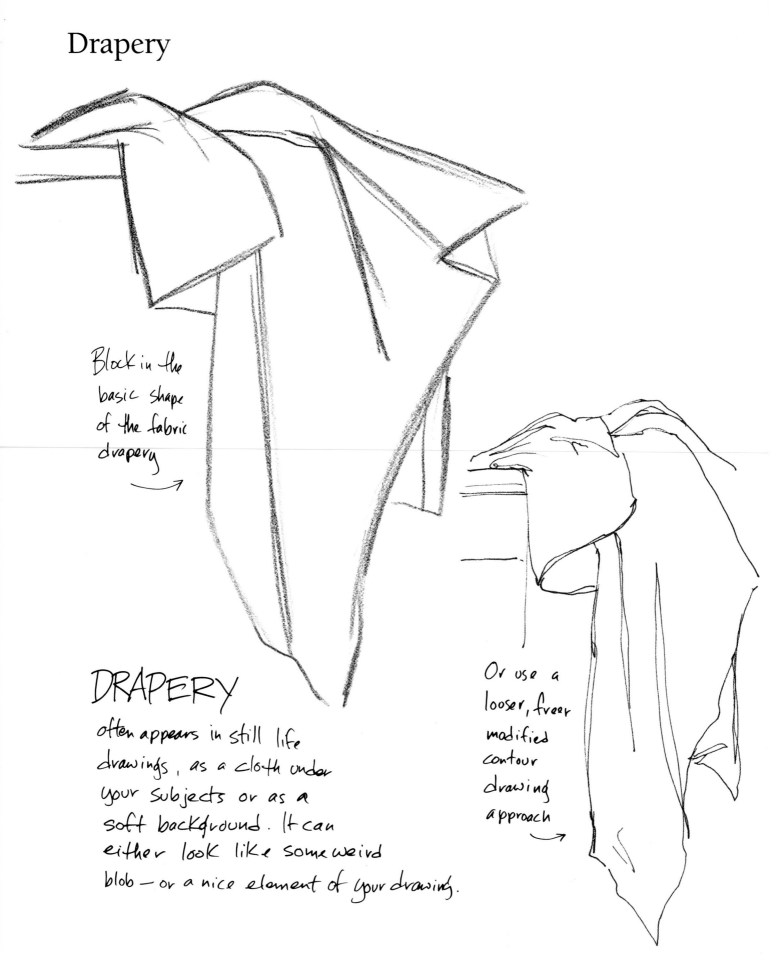

Block in the basic shape of the fabric drapery →

DRAPERY

often appears in still life drawings, as a cloth under your subjects or as a soft background. It can either look like some weird blob — or a nice element of your drawing.

Or use a looser, freer modified contour drawing approach →

Finishing Drapery

Now, add shadows, reflected lights, value patterns that give your drawing a sense of volume. Look carefully to see where to place the lightest lights and darkest darks.

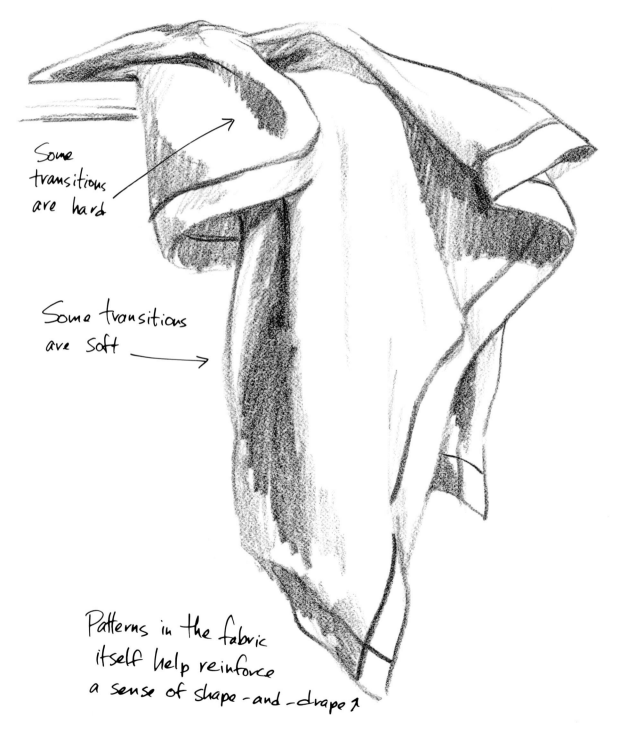

Some transitions are hard

Some transitions are soft ⟶

Patterns in the fabric itself help reinforce a sense of shape-and-drape ↗

Shiny Things

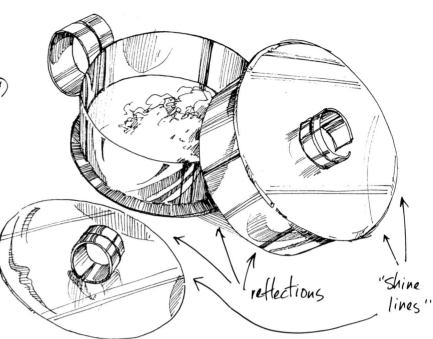

(Much the same as drawing glass, pg. 54)

Metal

watch for reflections and highlights. "Shine lines" also suggest highly polished metal. If you're working in black and white, you don't have to worry about reflected color.

reflections

"shine lines"

Make a simple map for yourself of the shine on metal — but keep it simple.

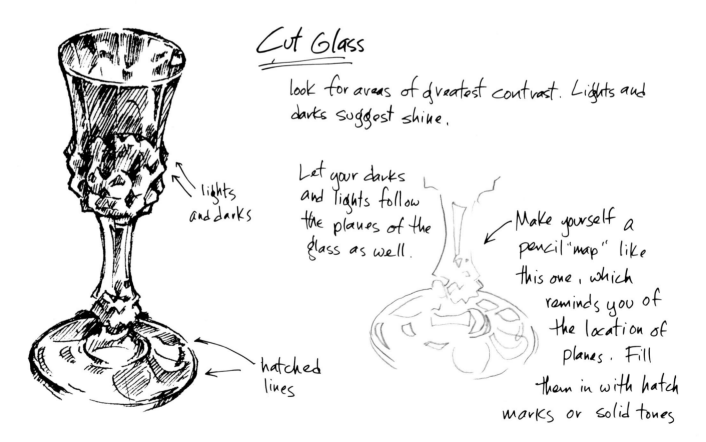

Cut Glass

look for areas of greatest contrast. Lights and darks suggest shine.

Let your darks and lights follow the planes of the glass as well.

lights and darks

hatched lines

Make yourself a pencil "map" like this one, which reminds you of the location of planes. Fill them in with hatch marks or solid tones

Rough Textures

Dots, dashes, zig-zag lines & squiggles

No shine here ↓

Here, there's virtually no shine to worry about — just how best to suggest the specific texture. Try a variety of mediums

This is black Prismacolor colored pencil (Shelf fungus)

Hatched lines suggest darker bark →

rough edges — splinters ↓

Here, I've tried to suggest the linear texture of a stick of firewood and the blobby roughness of the fungus that was growing on it

No shine here, either ↑

But on this old pottery ink bottle there's both rough texture (notice the hatched lines) and a bit of shine

dots help

Project:

Find a piece of wood, a rock or another rough-textured object. Practice a variety of ways of capturing that texture—dots, squiggles, crosshatched lines. Try to give it a sense of volume while you're at it.

Tree Shapes

tall, graceful

urn-shaped

rugged, irregular

tall oval

Lombardy poplar

Elm

Catalpa

Oak

triangular

Pine

TREE SHAPES.

though it's more fun to draw individual trees from life (like the thorny locust at right), sometimes basic tree shapes drawn according to species works well

very tall, with fronds

Palm

cedar

locust (note the thorns!)

Project:

Find as many different species of trees in your area as you can and roughly sketch their shapes. Refer to a field guide if necessary, to identify them, and label each. Notice what makes them different from each other—variety makes your drawing interesting.

Trees Through the Seasons

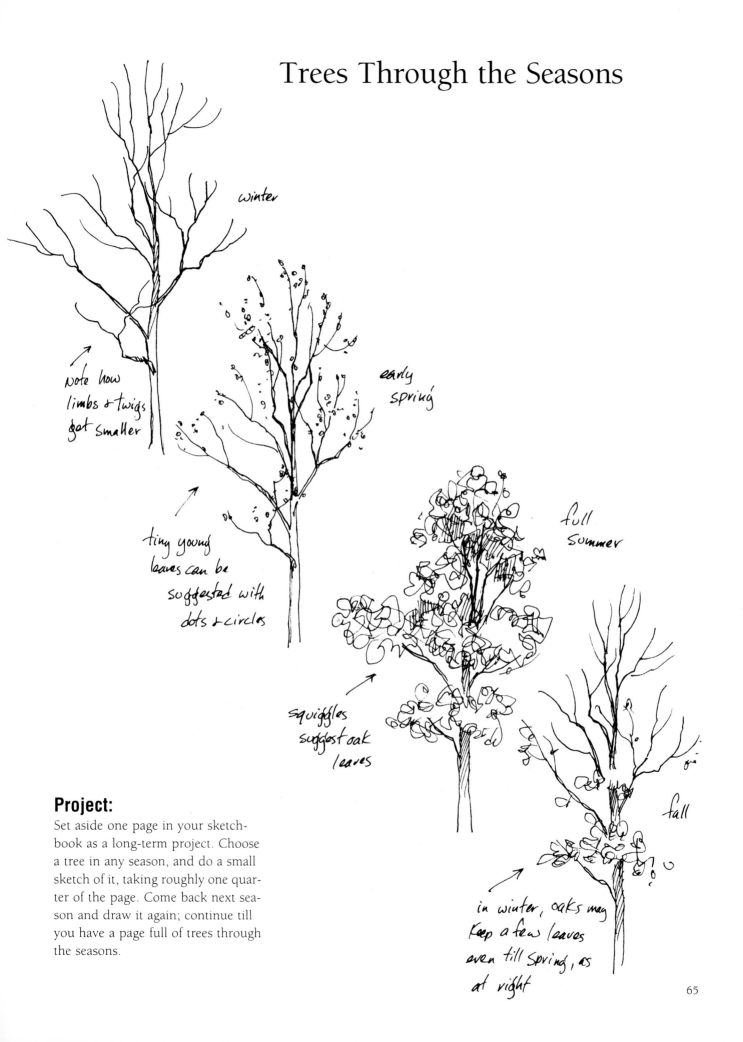

winter

Note how limbs & twigs get smaller

early spring

tiny young leaves can be suggested with dots & circles

full summer

squiggles suggest oak leaves

fall

in winter, oaks may keep a few leaves even till spring, as at right

Project:

Set aside one page in your sketch-book as a long-term project. Choose a tree in any season, and do a small sketch of it, taking roughly one quarter of the page. Come back next season and draw it again; continue till you have a page full of trees through the seasons.

More About Trees

TREES are individuals, too. These three pine trees have their family character-istics as well as individual quirks shaped by habitat and circumstance.

Shortleaf Pine

White Pine

Lodgepole Pine

So does this palm tree.

This generic pine and palm at right would get boring in a hurry!

Draw Generic Trees

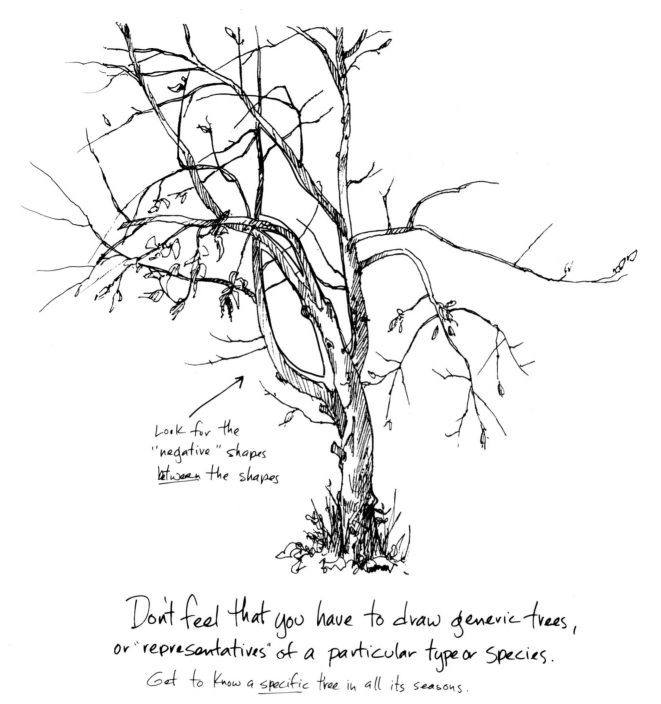

Look for the "negative" shapes between the shapes

Don't feel that you have to draw generic trees, or "representatives" of a particular type or species.
Get to know a specific tree in all its seasons.

Project:

Find a tree that's near enough to you that you can draw it on a regular basis, perhaps through the seasons. Pick one that's not too big or complex, like this little apple tree that happens to be in my front yard. Watch for negative shapes to help you draw the shape better.

← Rough bark

Something has drilled holes here

Close-up Details

Come in close for details like insect or woodpecker damage, weeds, or bark

A variety of weeds, dead and alive

Bare, gnarled wood on roots

Suggest bark with a variety of lines and hatching — this is walnut bark. Birch might be more like that at left, with smoother lines following the shape of the trunk

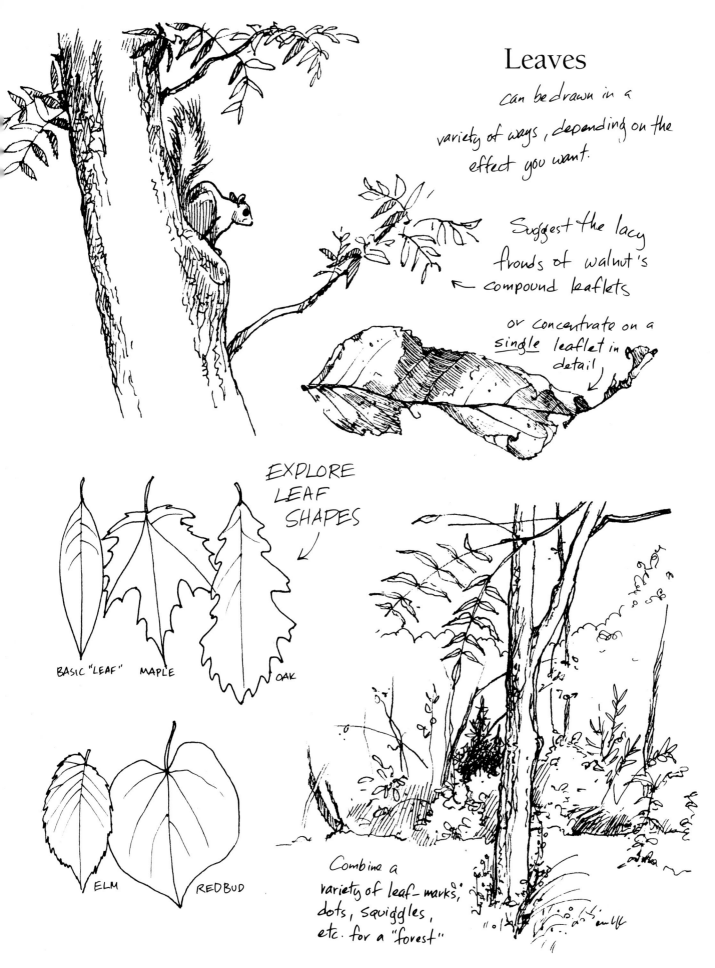

Leaves

can be drawn in a variety of ways, depending on the effect you want.

Suggest the lacy fronds of walnut's compound leaflets

or concentrate on a single leaflet in detail

EXPLORE LEAF SHAPES

BASIC "LEAF" MAPLE OAK

ELM REDBUD

Combine a variety of leaf-marks, dots, squiggles, etc. for a "forest"

Trees in the Forest

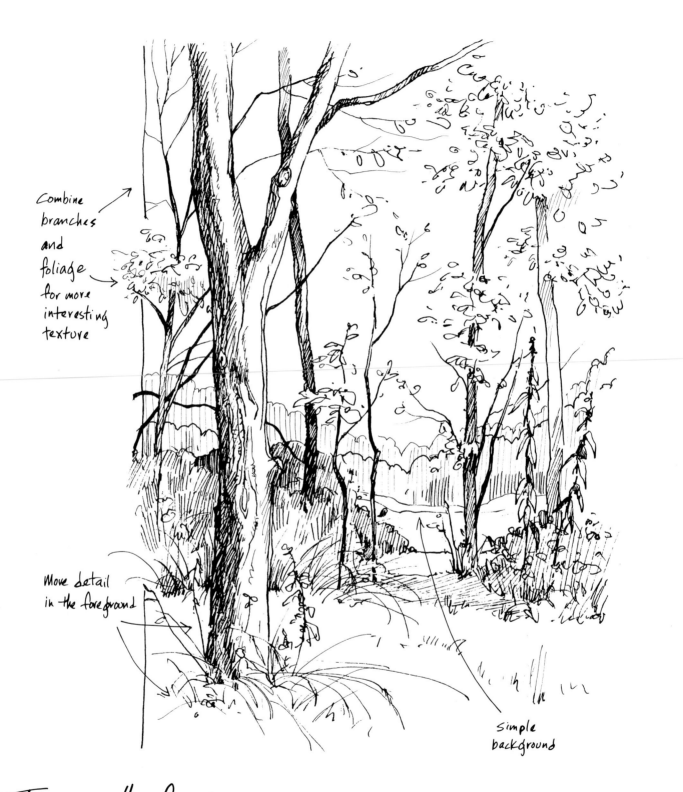

Combine branches and foliage for more interesting texture

More detail in the foreground

simple background

Trees in the forest — it isn't necessary to draw every branch and leaf — let details get less distinct the farther in the background they are

Distant Trees

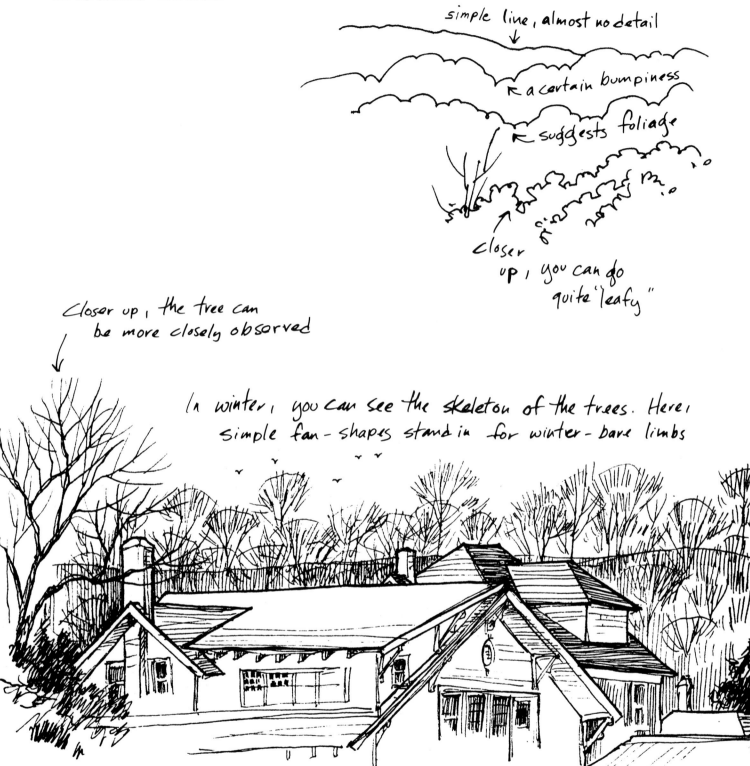

simple line, almost no detail ↓

← a certain bumpiness

← suggests foliage

Closer up, you can go quite "leafy"

Closer up, the tree can be more closely observed ↓

In winter, you can see the skeleton of the trees. Here, simple fan-shapes stand in for winter-bare limbs

Project:

Go to your local park or to the country. Sketch a small path through the woods, looking for ways to suggest depth and foliage.

Grass and Weeds

from a distance, you can suggest grass and weeds
with the simplest of broken or wavy lines,
as above

...or just suggest grass
waving in the wind

in the middle
ground, you may want
to suggest a variety of weed forms
or broadleaf foliage ...

gesture
sketch

close up, you can get into
actual types of weeds or
just enjoy a variety of
textures + shapes.

A Patch of Grass and Weeds

makes a nice study (think of Albrecht Dürer's "Small Piece of Turf.")

Project:

Choose a particular *small* patch of weeds and try to capture the feeling of at least half the weed species you see. It isn't necessary to do a botanical drawing—just a sketch.

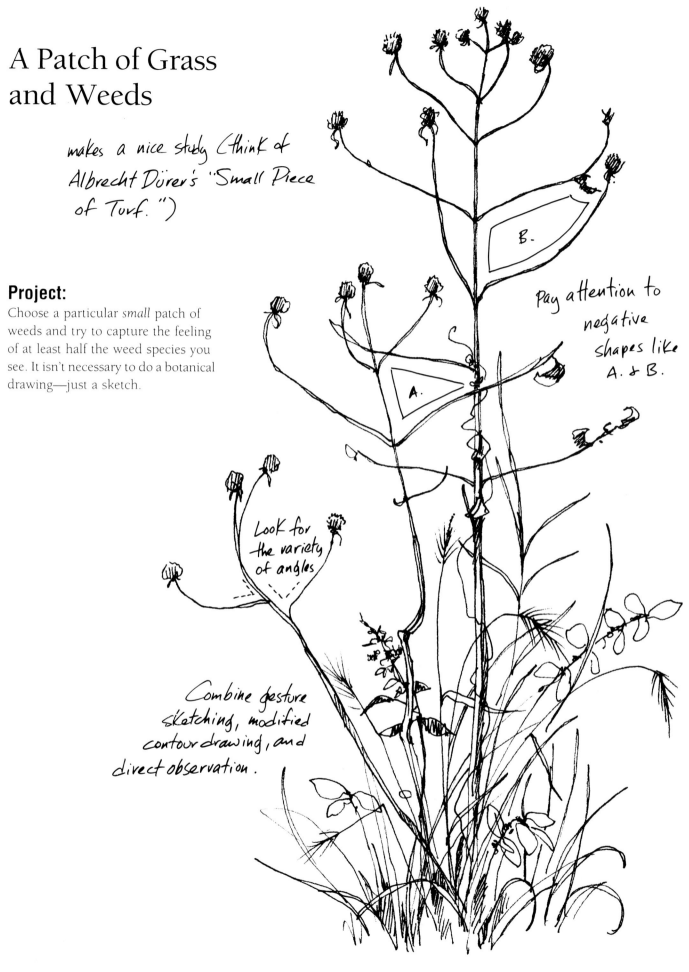

Pay attention to negative shapes like A. & B.

Look for the variety of angles

Combine gesture sketching, modified contour drawing, and direct observation.

Rock Forms

Use value to suggest shape and volume. Lines can suggest cracks and fissures.

overlap forms

Light and dark areas give a sense of form

Vary sizes and shapes

You can let your lines follow the shape of the rock, if you want.

Rocks

let shadows
suggest shapes

"fallen leaf"
squiggles

modified
contour
- drawing

ROCKS

that have come in contact with water
over a long period may be rounded as those Maine Coast
rocks on the last page were, or more subtly shaped,
like these that come into contact with water
more intermittently —only when the little creek is
actually running!

A variety of
small dots and
ovals suggests pebbles.

LIMESTONE
SANDSTONE
GRANITE,
ETC. — each
reacts differently
to the weathering
effects of wind
and water.

Project:

Find a comfortable place where there
are rocks of various sizes and shapes.
Try to capture the sense of direction
with light-and-dark values.

Rocks

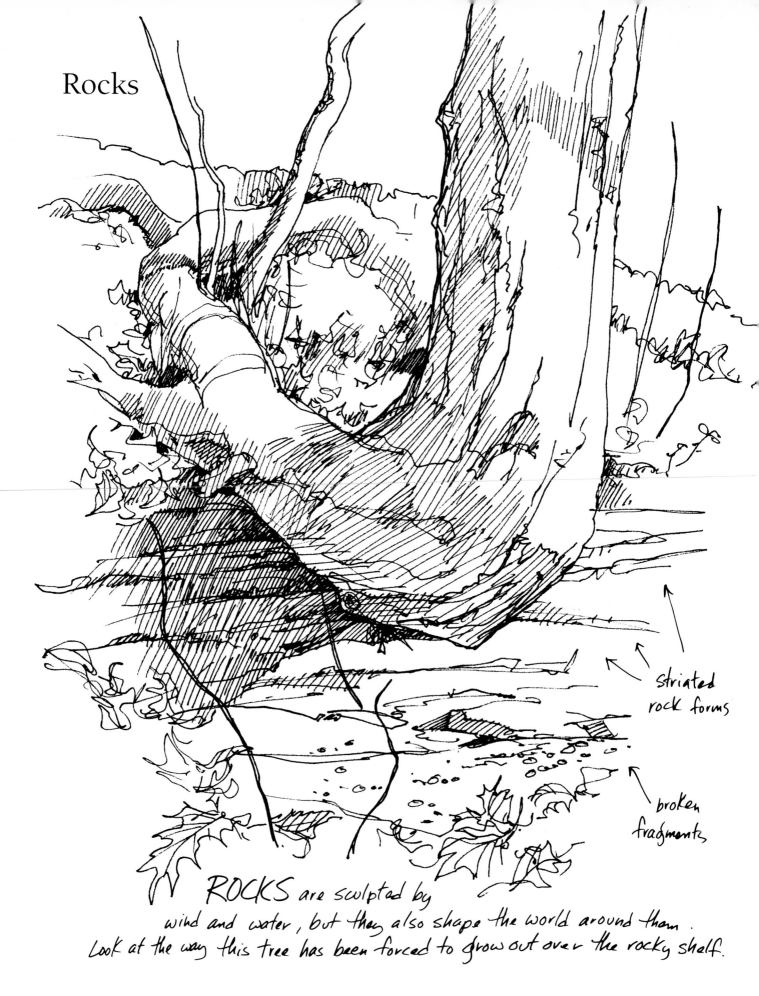

striated
rock forms

broken
fragments

ROCKS are sculpted by
wind and water, but they also shape the world around them.
Look at the way this tree has been forced to grow out over the rocky shelf.

Sandstone Rocks, Cliffs and Caves—

Sandstone rocks, cliffs, boulders and caves may be massive, sculpted and smoothed by time. Let shadows help define their shapes (crosshatching works well if you're drawing with ink, smoother tones if you're using pencil. Look for edges and smooth transitions.

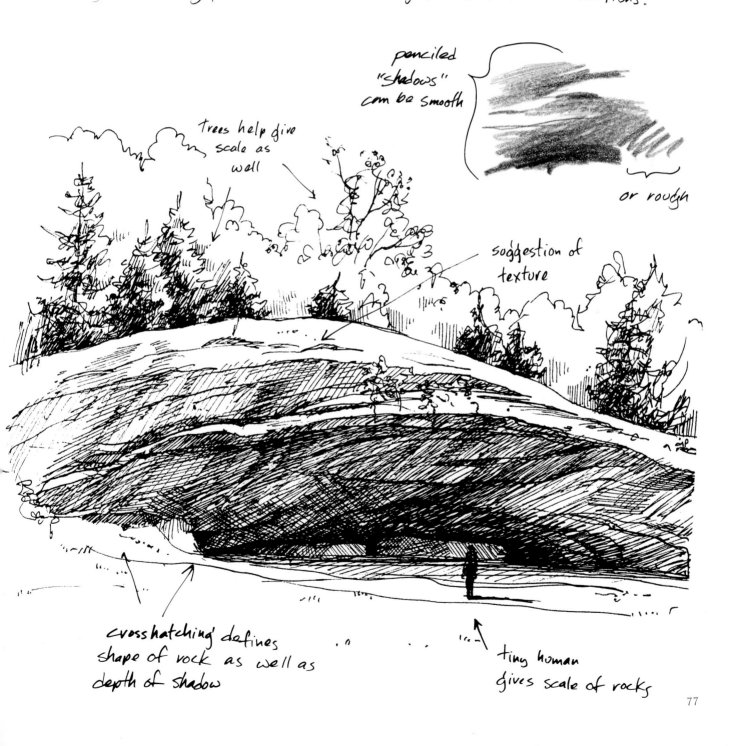

penciled "shadows" can be smooth

or rough

trees help give scale as well

suggestion of texture

crosshatching defines shape of rock as well as depth of shadow

tiny human gives scale of rocks

Placid Lake—

a slight breeze disturbs the glassy, reflective quality. Use lines to suggest smooth and ruffled water.

← Horizon is flat or nearly so

reflections of shadows

Horizontal lines squiggles suggest reflections

Fish jumped! Ovals + "splash" tell the tale

Wavy lines suggest waves close to the shore and among the water-weeds

show that weeds grow in the water

Project:

Even though the water is still, you can find details to draw. Try to draw a placid lake like this one, suggesting ripples near the shore, reflections— even a jumping fish. Remember to make the water's surface appear flat, which it does on almost all occasions.

Still-Water Reflections

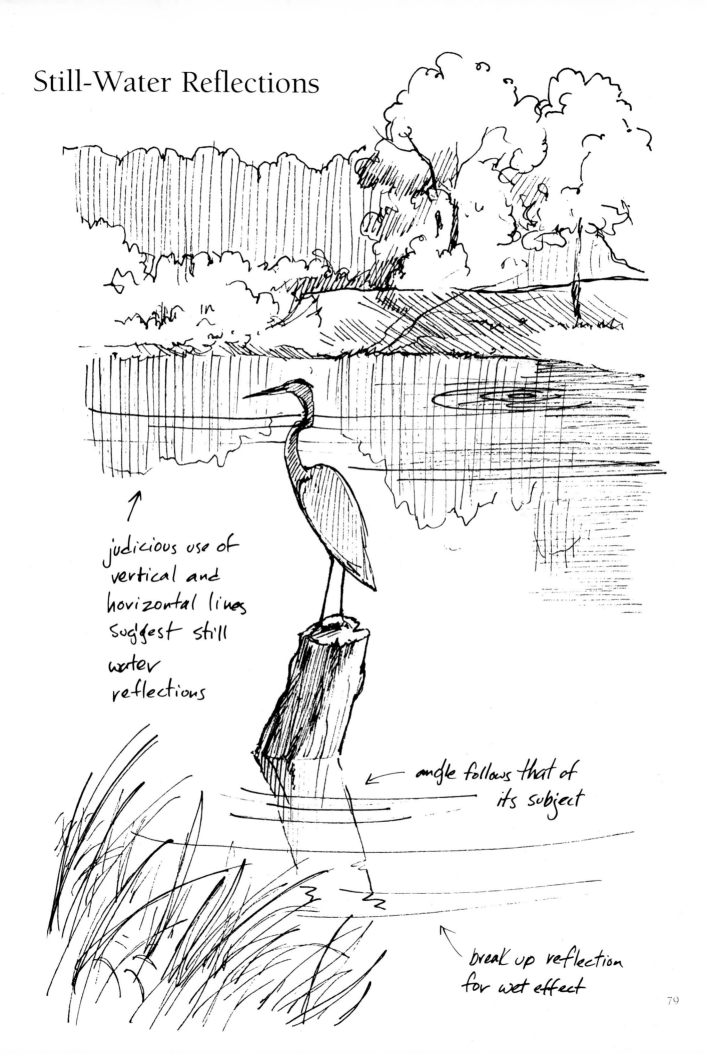

judicious use of
vertical and
horizontal lines
suggest still
water
reflections

angle follows that of
its subject

break up reflection
for wet effect

Still and Moving Water

Things change quickly when the water starts to move. The heron's mirror-image breaks up in the ripples, and downstream from a still pool the creek becomes much more active as it flows over rocks!

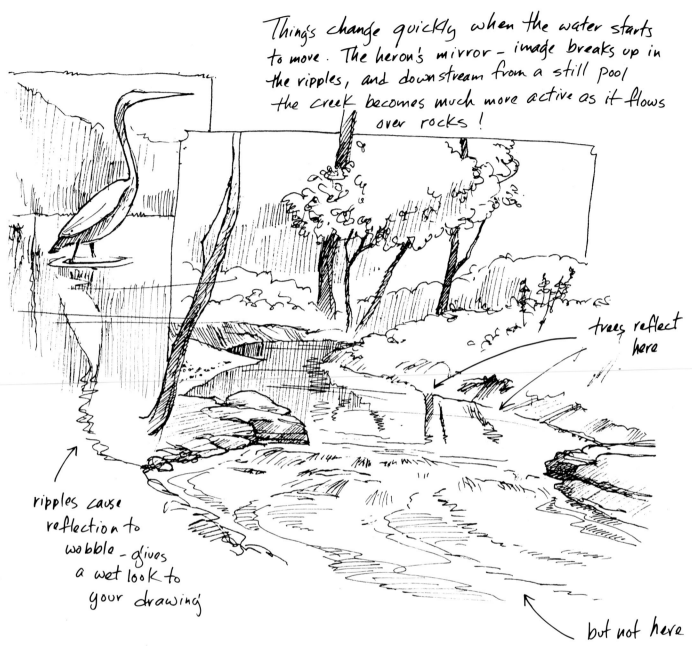

trees reflect here

ripples cause reflection to wobble - gives a wet look to your drawing

but not here

Try to see what's causing the water to form ripples and bubbles. Make a "map" of the water's movement.

Project:

Notice how different moving water looks from still water; reflections usually don't show at all. Find a small stream to draw, and try to "map out" the direction of water flow. Use curving lines and squiggles as well as hatching.

Falling Water

Water isn't always blue, green or brown. Sometimes it's white, especially when it has a lot of air mixed in (surf, waterfalls, white-water) or when it's frozen. Note the curve of a waterfall and the texture of the water.

darker where not much air is mixed in ↓

shadow behind water

curve

broken lines ↗

shadows in foam ←

foam on moving water ←

shadows on far bank ↑

shadows

remember, footprints appear smaller in the background

Frozen Water (SNOW)

Snow is easy to draw, in black and white, anyway, where the white of your paper stands in for the frozen covering. Draw shadows and footprints instead.

(this is snow on my frozen pond - that's why it's so level)

Drawing Skies and Clouds

← darkest

lightest ↑

* If you're using pencil (in this case, black Prismacolor colored pencil), you can suggest a sunny sky by grading from darker to lighter — or just leave the sky blank — I do!

* You can suggest high-flying mare's tail clouds with a few long strokes →

darker ↘

lighter

tallest, most rounded ↙

* Or pay attention to the shapes of cumulous clouds (and the value of the sky between them.)

↖ flatter closer to the horizon

↑ ↑ rain

* Here, I've suggested a variety of simple cloud shapes using line alone (no values.) I like this effect a lot.

Clouds From Above

Usually, cloud shapes follow a simple perspective — tallest & fluffiest on top, then flatter, then a _lot_ flatter, as in the previous examples and at right ⟶

But when you're up in an airplane you may be flying through or _over_ clouds. See if you can capture the interesting shapes and unusual perspective.

It may help you get past a certain — uh — nervousness about flying through thunder heads.

(It did me.)

Simple Buildings
in Landscape

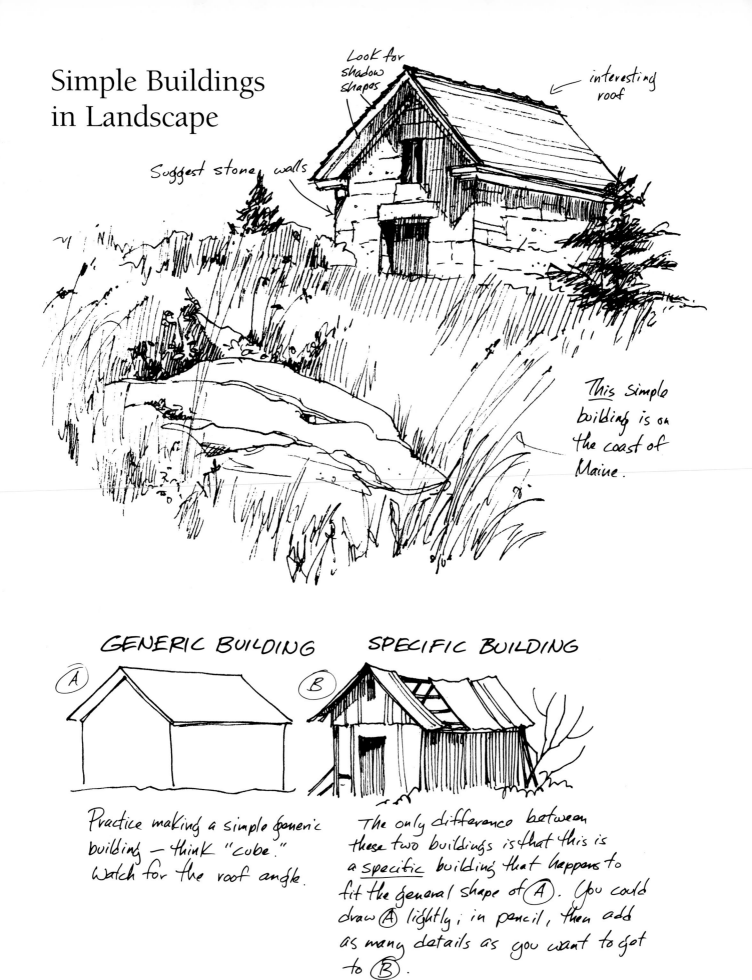

Look for shadow shapes

interesting roof

Suggest stone walls

This simple building is on the coast of Maine.

GENERIC BUILDING

(A)

Practice making a simple generic building — think "cube." Watch for the roof angle.

SPECIFIC BUILDING

(B)

The only difference between these two buildings is that this is a specific building that happens to fit the general shape of (A). You could draw (A) lightly, in pencil, then add as many details as you want to get to (B).

Buildings in Landscape

Fort Osage,
Sibley, MO

shading suggests form

logs

stone

hatching makes good shadows

Except for the large 3½ story building at right, these log buildings are mostly simple cubes. Texture is suggested with a few lines:

the corners where the logs meet

logs on the sides of the buildings

stone foundation

Keep details simple

Buildings in landscape can be kept quite simple, a single accent in your landscape, like the barn at left, or grouped as the subject itself, as above

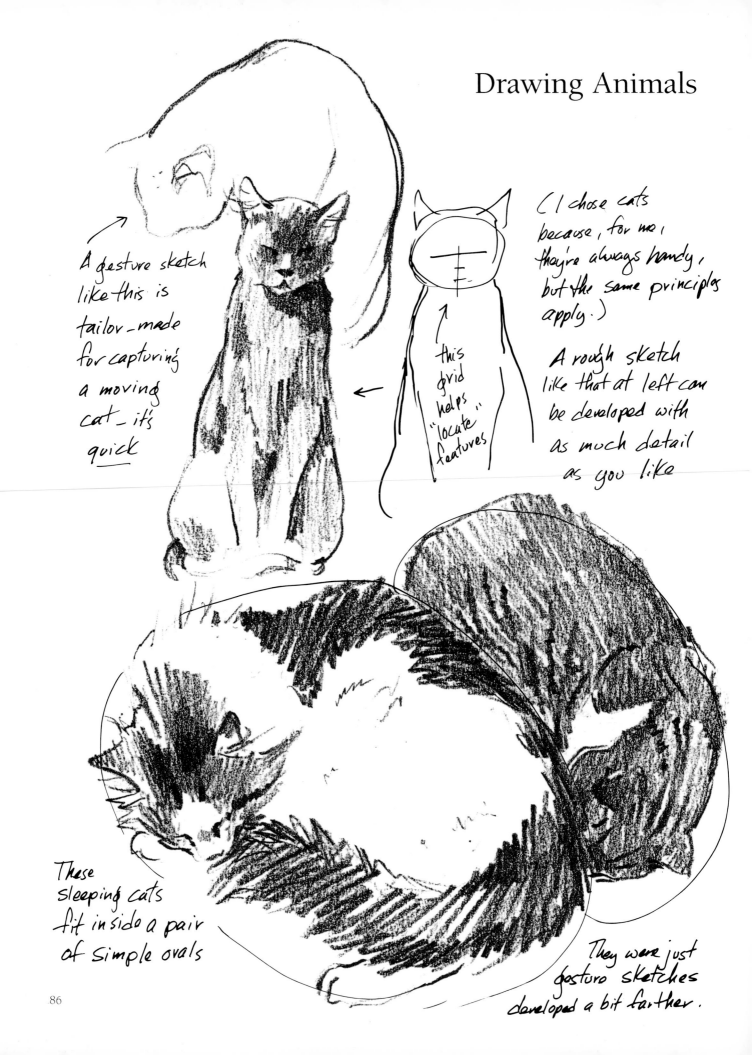

A gesture sketch like this is tailor-made for capturing a moving cat — it's quick

(I chose cats because, for me, they're always handy, but the same principles apply.)

this grid helps "locate" features

A rough sketch like that at left can be developed with as much detail as you like

These sleeping cats fit inside a pair of simple ovals

They were just gesture sketches developed a bit farther.

Animals in Landscape

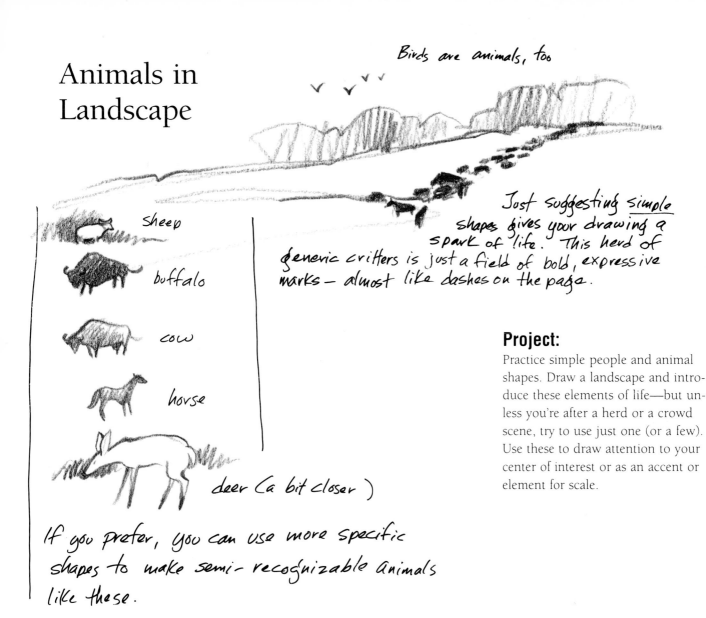

Birds are animals, too

Sheep

buffalo

cow

horse

deer (a bit closer)

Just suggesting simple shapes gives your drawing a spark of life. This herd of generic critters is just a field of bold, expressive marks — almost like dashes on the page.

If you prefer, you can use more specific shapes to make semi-recognizable animals like these.

Project:

Practice simple people and animal shapes. Draw a landscape and introduce these elements of life—but unless you're after a herd or a crowd scene, try to use just one (or a few). Use these to draw attention to your center of interest or as an accent or element for scale.

People in Your Drawings

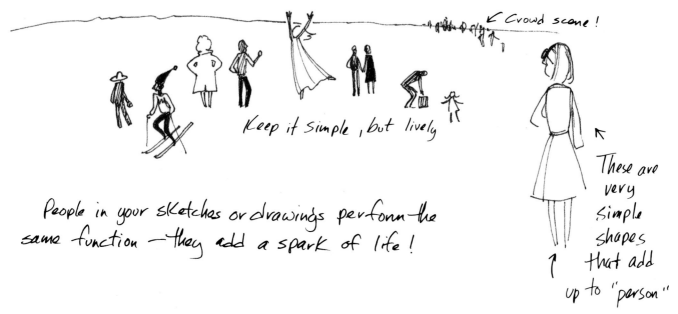

Crowd scene!

Keep it simple, but lively

These are very simple shapes that add up to "person"

People in your sketches or drawings perform the same function — they add a spark of life!

Adding Color

Color can be added to a pencil drawing such as this black Prismacolor colored pencil drawing.

Lay washes in loosely, letting them blend.

bluer green pushes this back

It's almost like making your own coloring book!

blend or let edges dry thoroughly, like those between the building and the cedar tree

Use color to express your mood or the mood of your subject, to suggest distance, to capture local color, to depict season or time of day — it's MAGIC.

Using Sketchy Lines in Color

Even though you've added the dimension of color to your sketches, don't feel you have to make them tighter and more detailed — unless you just want to. This rough sketch of a clump of maple trees is an example — I used very loose, sketchy lines to suggest the overall shapes as well as the play of light and dark. Be inspired by that play — let your colors suggest warm light and cool shadow. It's not necessary to try to draw exactly the colors you see!

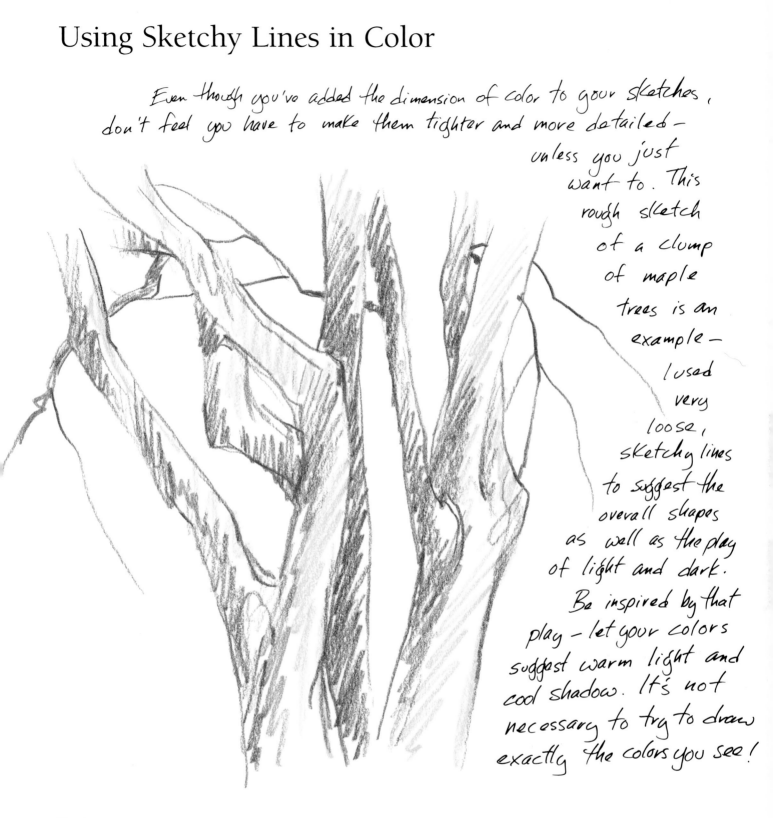

Project:

Find a relatively simple subject and simplify it further by drawing it with loose, sketchy lines. Use color boldly!

Drawing Skies
in Color

more pressure

↑

↓

less pressure

This can be particularly satisfying— or particularly frustrating, depending on the medium, the effect you're after, and —who knows? — the phase of the moon.

Dry media like colored pencils are easiest to control, but with a bit of practice, water-soluble mediums will behave as well.

When adding color— as at sunrise or sunset, start with only a few — this can get garish in a hurry!

} just these 4 were enough!

With colored pencil, graduate from darker to lighter by applying more pressure on top, then a lighter and lighter touch as you work down

With water-soluble colored pencil, the basic process is the same —just blend with clear water on a brush

←— Dry —→ ←— Wet —→

Squiggly, sweeping lines can be blended nicely with clear water to suggest sunrise or sunset

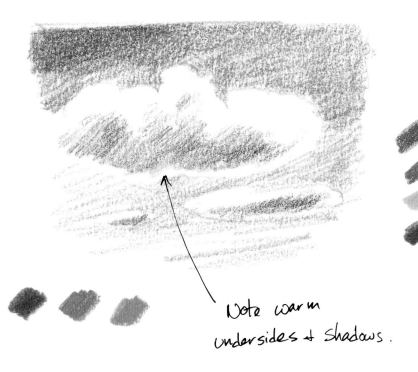

Drawing Skies in Color

Now, try adding a few clouds. Remember that the largest, fluffiest clouds are usually at the top. Sky color still needs to be graded from darker to lighter. This drawing is done in colored pencil.

Note warm undersides & shadows.

Try the same kind of cloud-filled sky by drawing in the rough shapes in pencil or black Prisma-color colored pencil. Then add quick washes of color, letting them blend in the clouds & keeping those whites <u>white</u>.

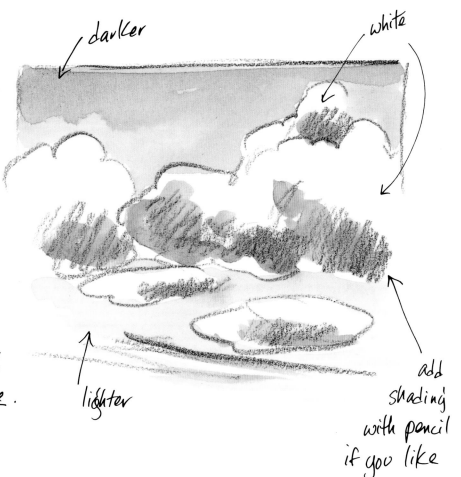

darker

white

lighter

add shading with pencil if you like

Drawing Water in Color

Don't just assume water is blue, period—that's generally just when it reflects a blue sky, unless it's full of minerals or other special circumstances. Gray sky, gray water. Or brown if it's muddy, or green. Look carefully. It may be sky blue, brownish-green up close, and multicolored where it reflects far objects.

far trees and bank, in reflection, are foreshortened, darker, and cooler, usually

squiggly reflections

ripples

muddy near bank

Project:

Draw a lake or pond on a quiet day. Watch for changes in color and texture. Using colored pencils, try to capture the mood of what you see.

moving water has little reflection

Things may change dramatically when water is in motion. Make yourself a map — in black and white first if you like — to see why patterns form as they do.

draw the patterns of water falling over rocks

Some reflections in the big pool — it's stiller, but still moving

sky

rock reflections

muddy bottom

Suggesting Reflections in Moving Water

Here, there are a variety of factors at work. If you look toward the light, moving water looks one way. If the light is at your back, it looks entirely different. If it's whitewater, forget it!

Drawing Fruit in Color

Start with something fairly simple, like an apple. Draw its basic shape, first.

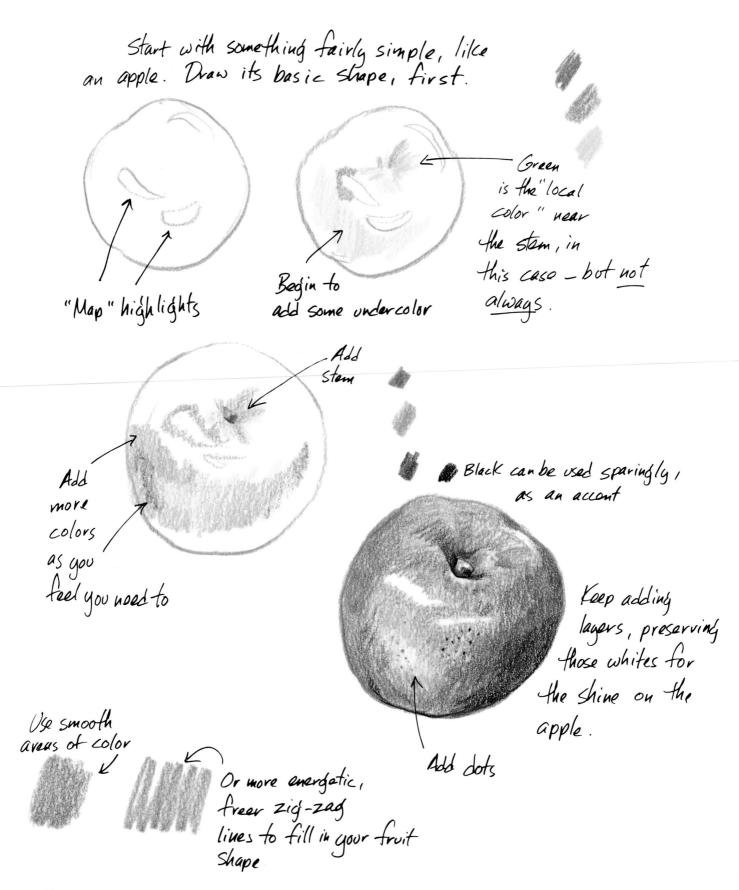

"Map" highlights

Begin to add some undercolor

Green is the "local color" near the stem, in this case — but not always.

Add stem

Add more colors as you feel you need to

Black can be used sparingly, as an accent

Keep adding layers, preserving those whites for the shine on the apple.

Add dots

Use smooth areas of color

Or more energetic, freer zig-zag lines to fill in your fruit shape

Drawing Fruit in Color

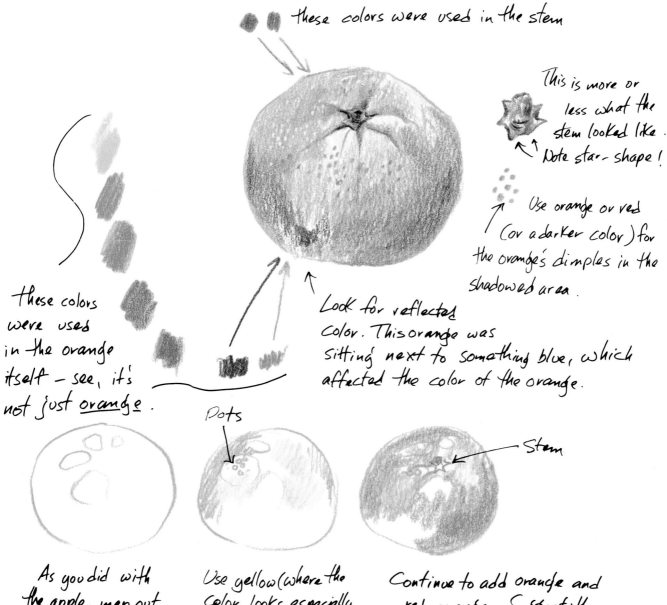

these colors were used in the stem

This is more or less what the stem looked like. Note star-shape!

Use orange or red (or a darker color) for the orange's dimples in the shadowed area.

Look for reflected color. This orange was sitting next to something blue, which affected the color of the orange.

these colors were used in the orange itself — see, it's not just <u>orange</u>.

Dots

Stem

As you did with the apple, map out the highlights and draw the basic shape.

Use yellow (where the color looks especially bright) for an under-coat. Make dot-shaped impressions in the paper, which will stay white when you lay color over them.

Continue to add orange and red-orange. Suggest the stem.

Project:

Choose a relatively simple fruit shape, or several to combine in one drawing. Using a combination of modified contour drawing and direct observation, sketch in the basic shape. Then, add color—watch carefully for reflected colors in shadows. Pick your favorite fruit!

Drawing Flowers in Color

These are down with colored felt-tip markers – you get a very linear effect. But if you want to soften your drawing you can wet it with clear water to blend it somewhat

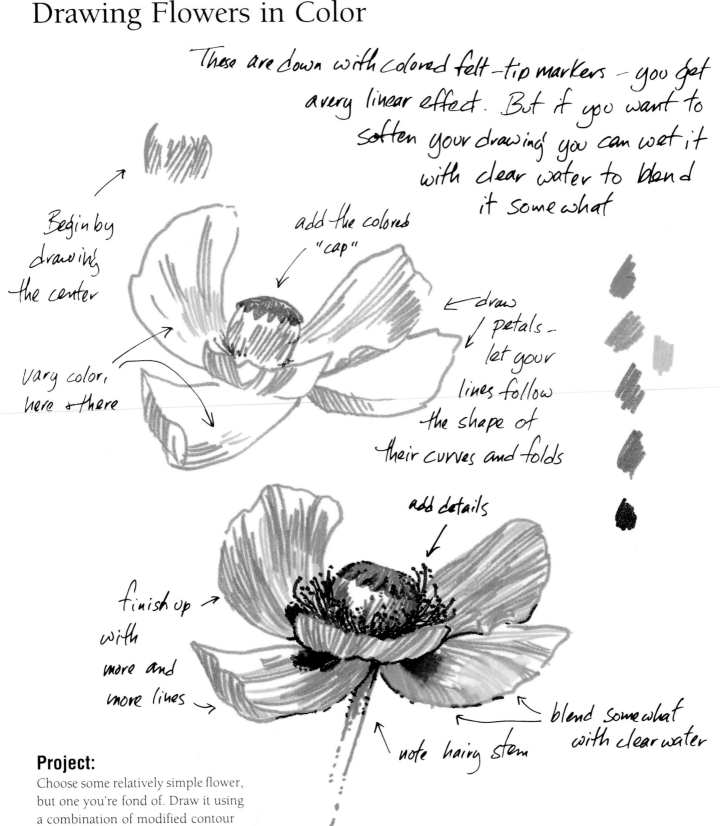

Begin by drawing the center

add the colored "cap"

Vary color, here & there

draw petals – let your lines follow the shape of their curves and folds

add details

finish up with more and more lines →

blend somewhat with clear water

note hairy stem

Project:

Choose some relatively simple flower, but one you're fond of. Draw it using a combination of modified contour drawing and direct observation. Use light and shadow to accentuate the flower's shape, and try to capture color as you see it.

Drawing Flowers in Color

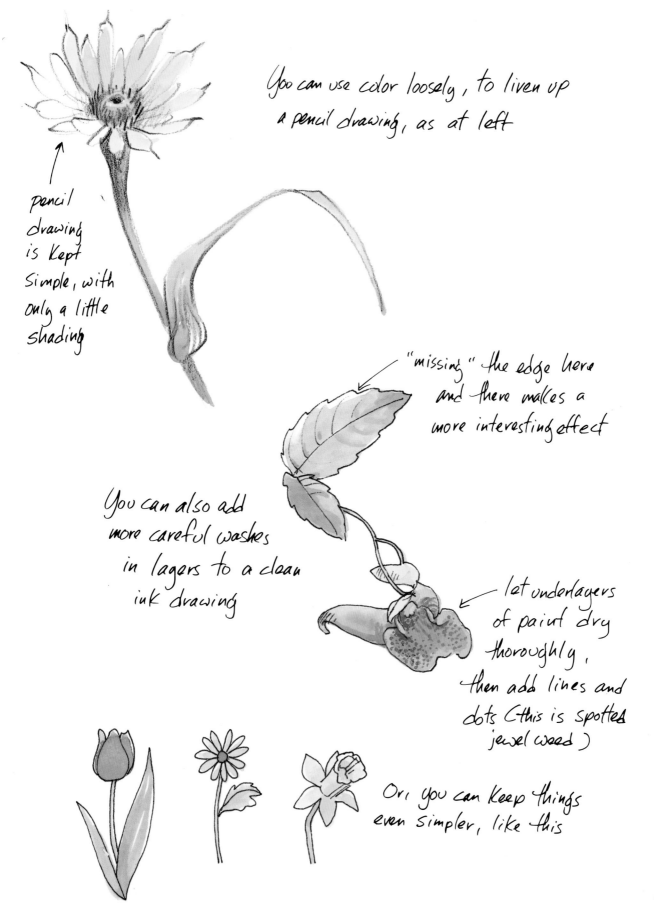

You can use color loosely, to liven up a pencil drawing, as at left

pencil drawing is kept simple, with only a little shading

"missing" the edge here and there makes a more interesting effect

You can also add more careful washes in layers to a clean ink drawing

let underlayers of paint dry thoroughly, then add lines and dots (this is spotted jewel weed)

Or, you can keep things even simpler, like this

Emphasize
Color
Relationships

Look for ways to emphasize color
relationships. Repeated colors help
to unify your drawing —
and in the fall when color abounds, you really
need to look for ways to provide unity!

all
these
colors!

Push the Color—

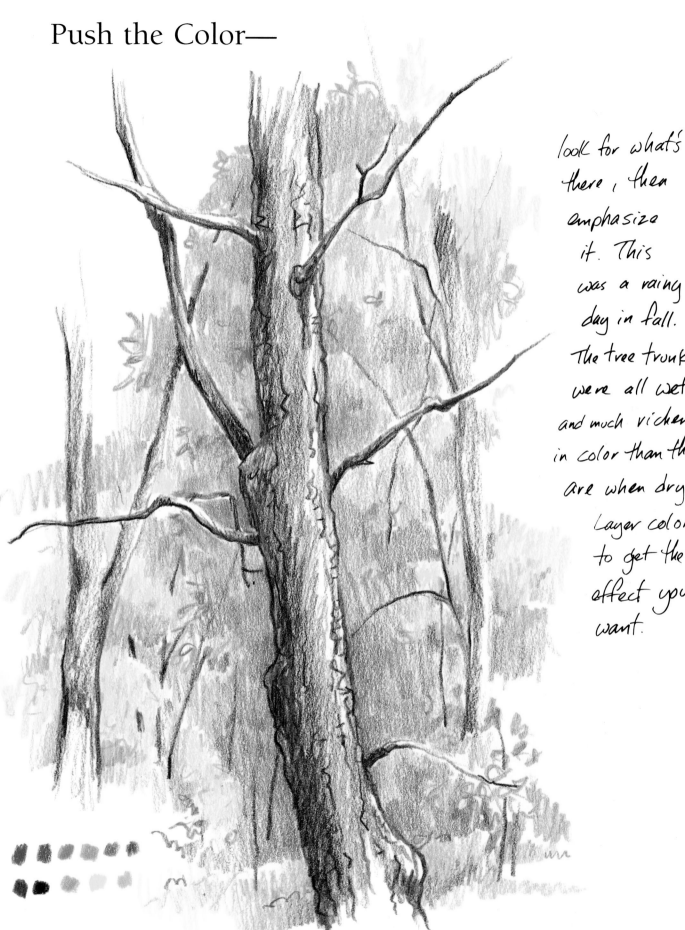

look for what's there, then emphasize it. This was a rainy day in fall. The tree trunks were all wet and much richer in color than they are when dry. Layer colors to get the effect you want.

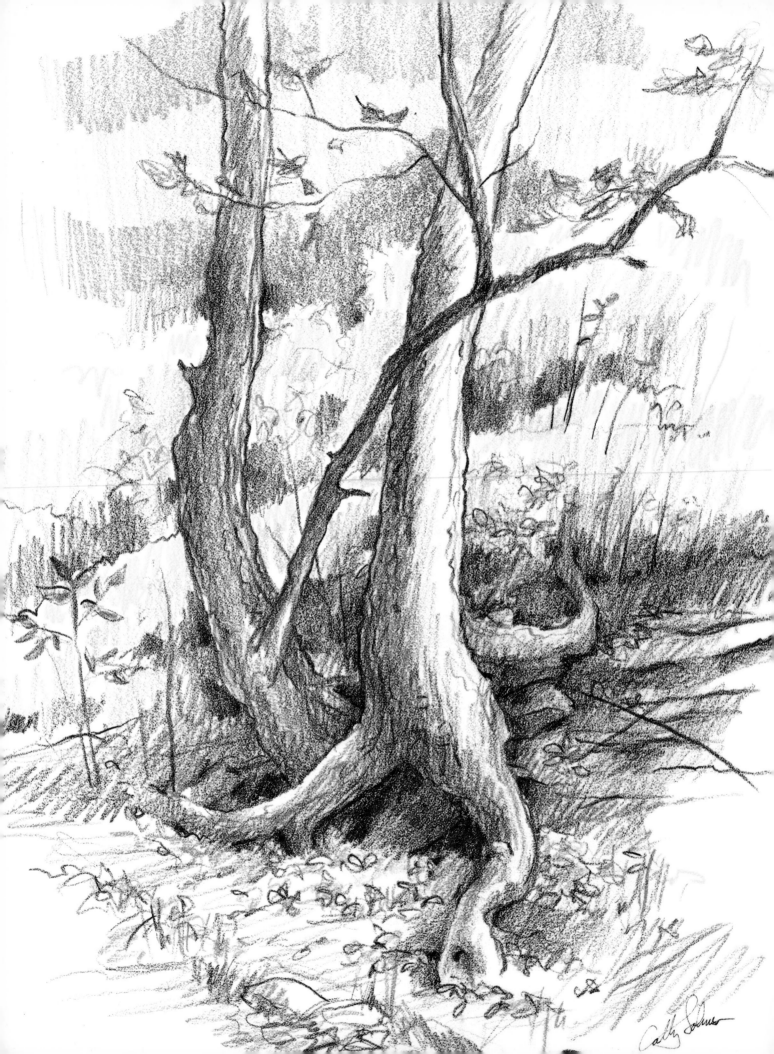

PUTTING IT ALL TOGETHER

You've learned how to make a variety of specific things—trees, water, fruits, flowers. You've gotten in some practice in seeing, and you've discovered new ways to work with your tools. Now you can put it all together into a finished drawing.

The term "finished drawing" might be a little misleading, though. It can mean many things to many people. To some, a drawing isn't finished until it looks like a black-and-white photo, every gradation of tone in place, every detail fully explored. If that's you, go for it. Others of us prefer a sketchier, more half-finished look that invites the viewer to complete the picture with his or her imagination. Still others are happy with a single, dancing line—if it expresses what you're after, then it is indeed a finished drawing.

You may want, though, to put together several of the things we've learned—a tree reflected in water, for instance, or a person walking through a garden. You want to explore things like composition and format, to see how they can affect your finished product. You'll even want to explore some simple rules of perspective, so your buildings won't look like they've been through the San Francisco earthquake!

Come along and try our examples, or take off on projects of your own. By now, you're ready to fly.

Format

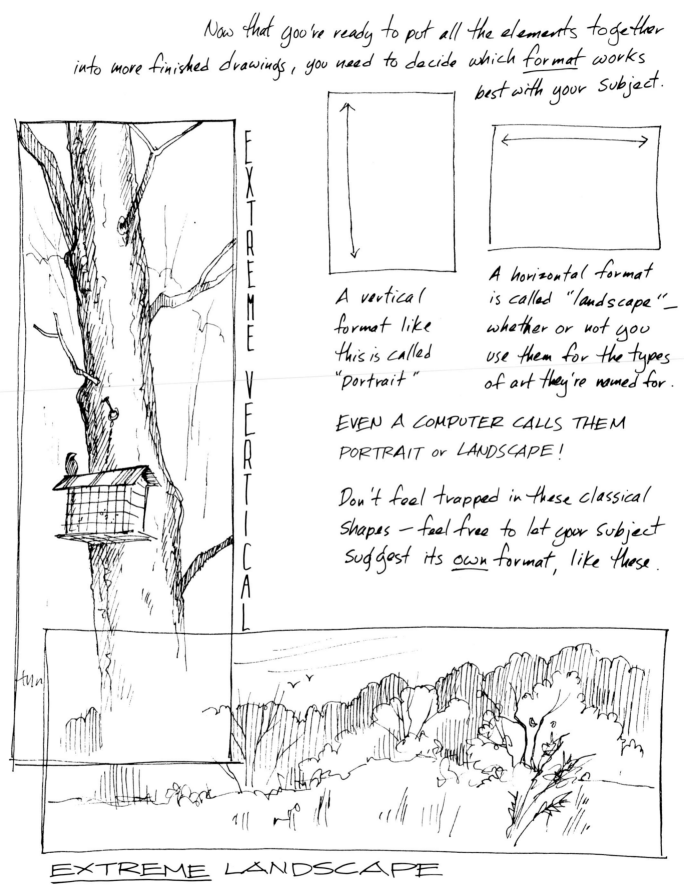

Now that you're ready to put all the elements together into more finished drawings, you need to decide which _format_ works best with your subject.

A vertical format like this is called "portrait"

A horizontal format is called "landscape"— whether or not you use them for the types of art they're named for.

EVEN A COMPUTER CALLS THEM PORTRAIT or LANDSCAPE!

Don't feel trapped in these classical shapes — feel free to let your subject suggest its _own_ format, like these.

EXTREME VERTICAL

EXTREME LANDSCAPE

Composition

It's usually best not to let your picture be divided dead center — by the horizon, the edge of a table, whatever.

Instead, let it fall above or below that point (a little or a lot).

The same holds true, of course, if you're working on a vertical painting.

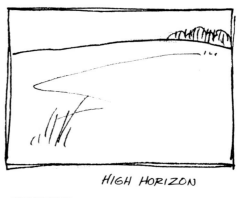

HIGH HORIZON

LOW HORIZON

THE "GOLDEN MEAN"

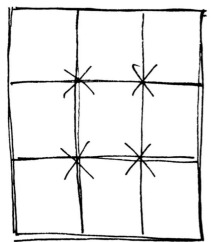

BETTER!

In placing your center of interest, divide your page in thirds (you can do this in your mind's eye only.) Then let the most interesting thing in your drawing fall at one of those points. (You can let secondary things fall at some of the others — but not all.)

BORING!

Here, the center of interest is placed dead center. This can be dull & boring (though there are exceptions.)

103

Linear Perspective

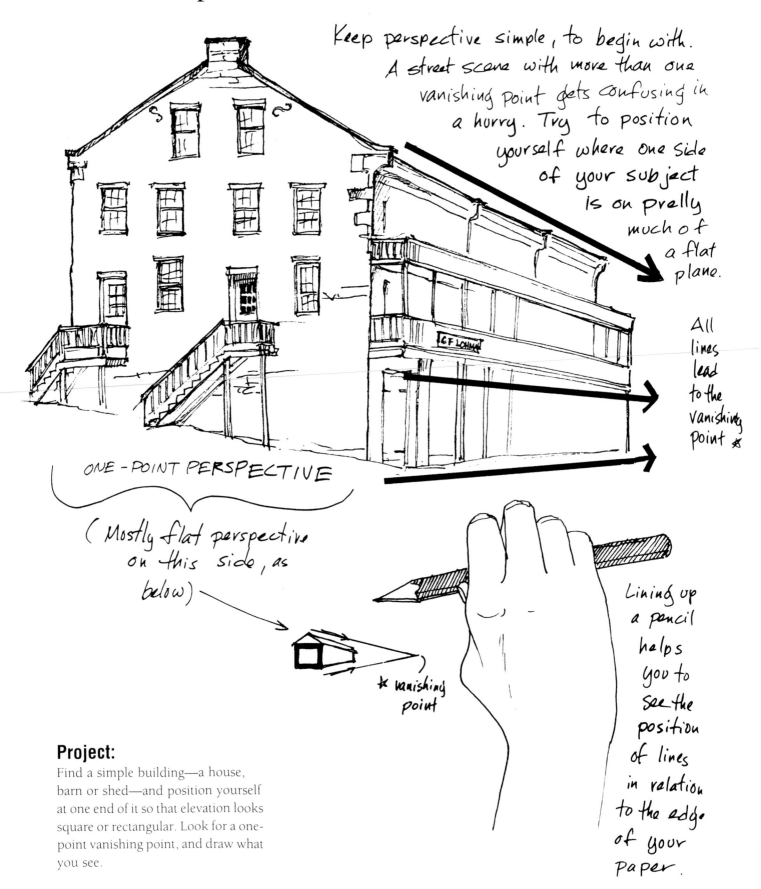

Keep perspective simple, to begin with. A street scene with more than one vanishing point gets confusing in a hurry. Try to position yourself where one side of your subject is on pretty much of a flat plane.

All lines lead to the vanishing point ✳

ONE-POINT PERSPECTIVE

(Mostly flat perspective on this side, as below)

✳ vanishing point

Lining up a pencil helps you to see the position of lines in relation to the edge of your paper.

Project:

Find a simple building—a house, barn or shed—and position yourself at one end of it so that elevation looks square or rectangular. Look for a one-point vanishing point, and draw what you see.

Perspective in Nature

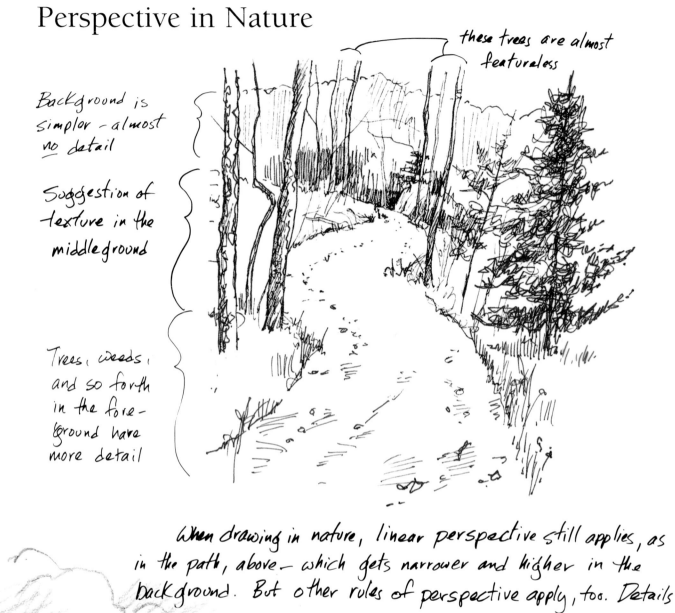

these trees are almost featureless

Background is simpler - almost <u>no</u> detail

Suggestion of texture in the middleground

Trees, weeds, and so forth in the fore-ground have more detail

When drawing in nature, linear perspective still applies, as in the path, above — which gets narrower and higher in the background. But other rules of perspective apply, too. Details become much simpler the farther back you look - note the tree trunks and background hill, above.

Or, you can use soft pencils in the foreground and progressively harder as you move back — or let shades of value suggest this atmospheric perspective. Generally, the background will be lighter, as at left.

Drawing a Simple Still Life

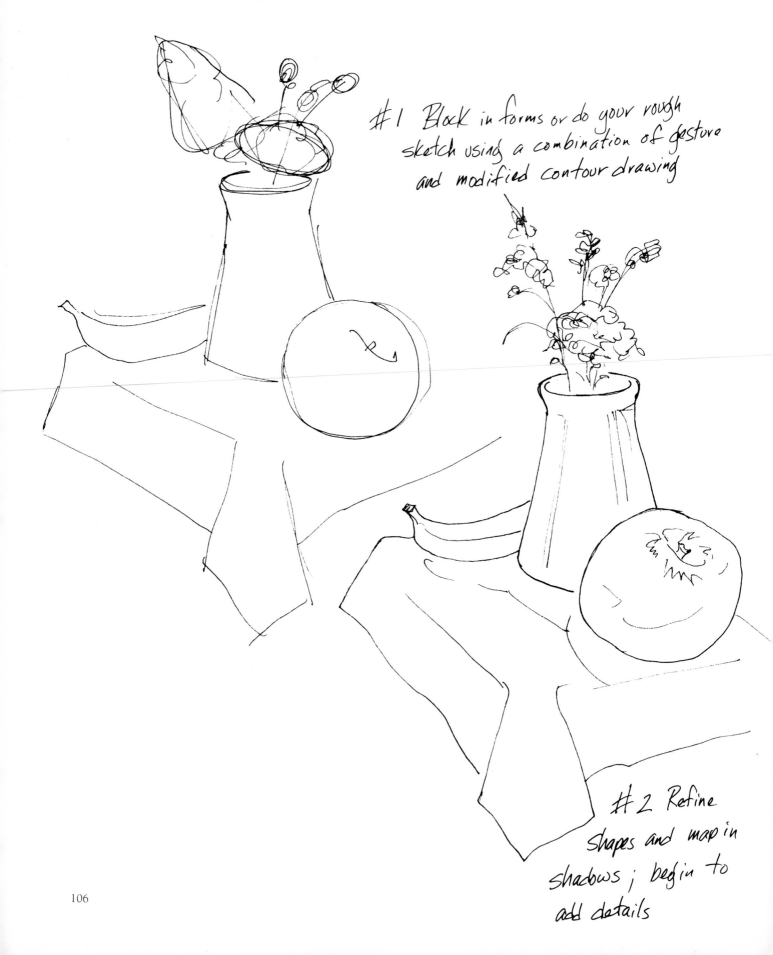

#1 Block in forms or do your rough sketch using a combination of gesture and modified contour drawing

#2 Refine shapes and map in shadows; begin to add details

Finish your drawing to whatever degree you want. Pay attention to textures, highlights, shadows and details. Try hatching and crosshatching, dots and dashes, squiggly lines — or branch out and use a pencil for broader areas of value,

as below

squiggly lines add value as well as texture

shading here defines shape of flower head

add details

lines reinforce shape

dots suggest texture

hatching and cross-hatching for value and form

Project:
Collect some simple shapes and place them in a pleasing arrangement. Draw what you see, carefully paying attention to lights and darks.

decorative line helps this to "read" as cloth

Complex Still Life

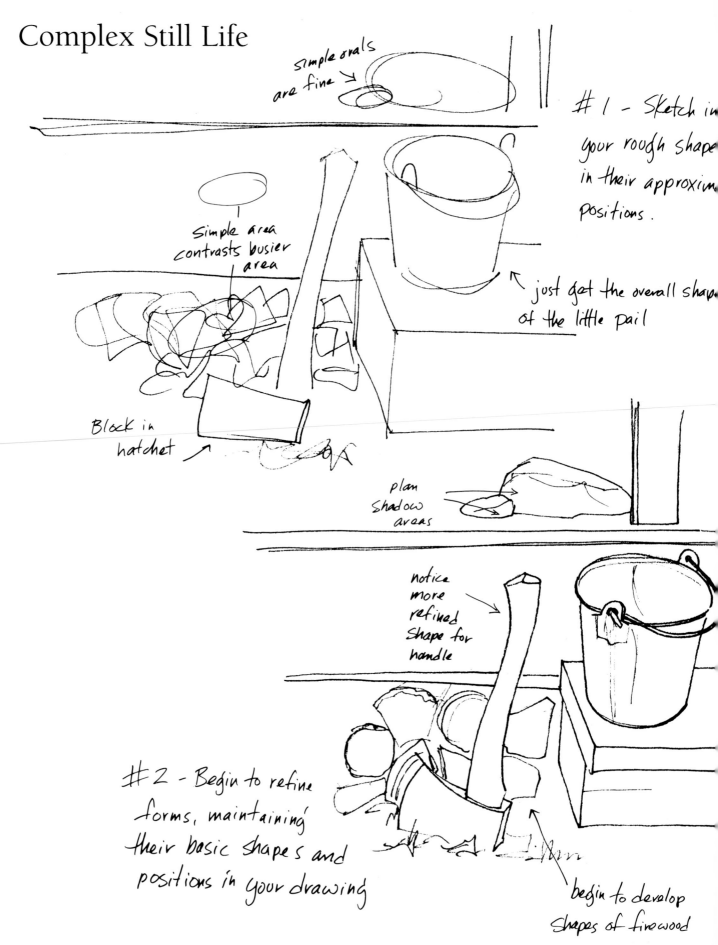

simple ovals are fine

#1 – Sketch in your rough shape in their approxim positions.

Simple area contrasts busier area

just get the overall shap of the little pail

Block in hatchet

plan shadow areas

notice more refined shape for handle

#2 – Begin to refine forms, maintaining their basic shapes and positions in your drawing

begin to develop shapes of firewood

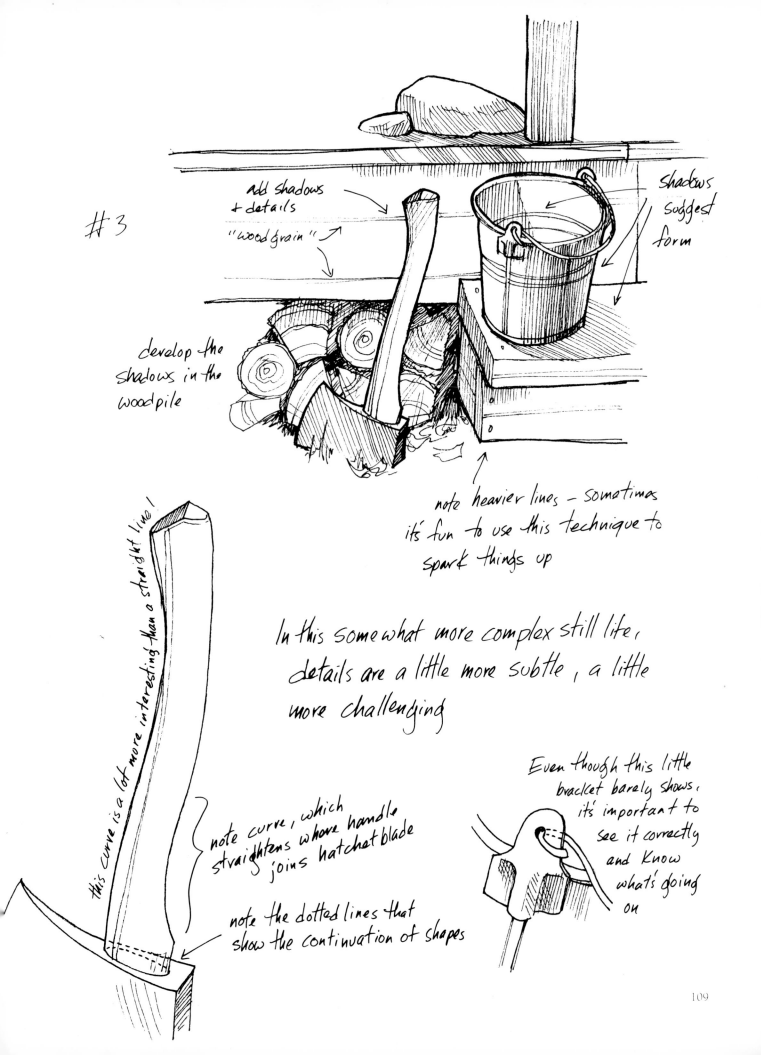

3

add shadows
+ details
"wood grain"

shadows
suggest
form

develop the
shadows in the
woodpile

note heavier lines — sometimes
it's fun to use this technique to
spark things up

In this somewhat more complex still life,
details are a little more subtle, a little
more challenging

this curve is a lot more interesting than a straight line!

note curve, which
straightens where handle
joins hatchet blade

note the dotted lines that
show the continuation of shapes

Even though this little
bracket barely shows.
it's important to
see it correctly
and know
what's doing
on

109

Simple Landscape With Barn

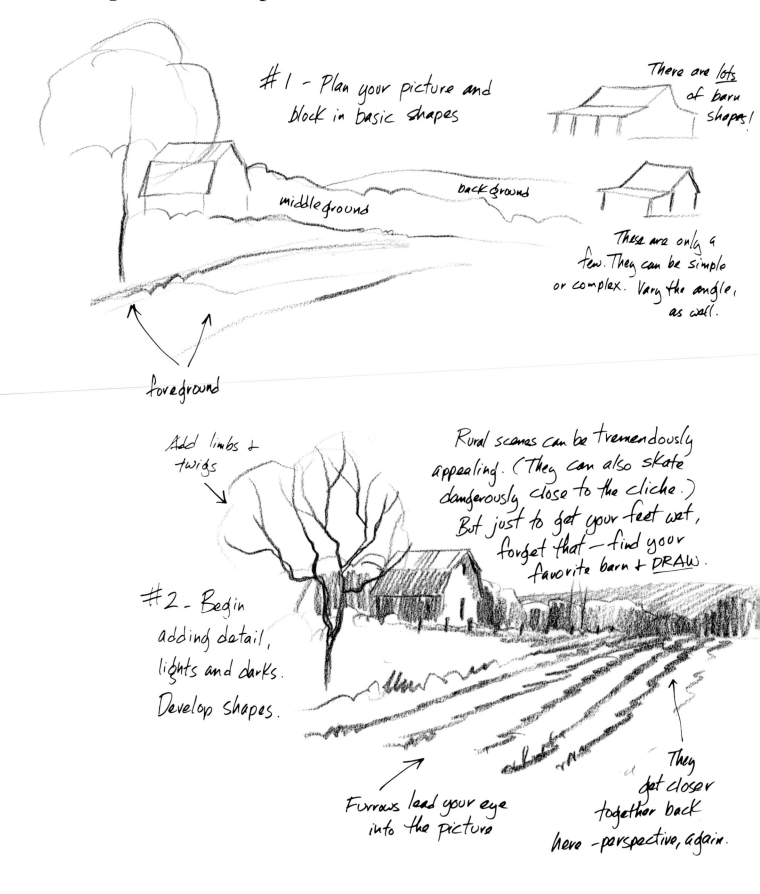

#1 - Plan your picture and block in basic shapes

There are *lots* of barn shapes!

middleground

background

These are only a few. They can be simple or complex. Vary the angle, as well.

foreground

Add limbs + twigs

Rural scenes can be tremendously appealing. (They can also skate dangerously close to the cliche.) But just to get your feet wet, forget that — find your favorite barn + DRAW.

#2 - Begin adding detail, lights and darks. Develop shapes.

Furrows lead your eye into the picture

They get closer together back here - perspective, again.

Suggestion of leaves

scudding clouds

pale background hill

add tone

#3 Finish the landscape to whatever
degree you wish. If you're working in a more precise medium
like pen and ink, you can get quite detailed, like the little
barn, below. Or stop at step 2, if you like
it better (I do) — it's your drawing.

Project:

Draw different types of buildings.
Keep the perspective simple at first,
and place them in a landscape. Exper-
iment with various degrees of fin-
ish—make some sketchy and some
very detailed.

Landscape With Water
and Reflections

remember tree shapes, Chapter 3 ➡

note relatively flat edge

lines all
suggest water

#1 - Lay in rough
shapes of water and
the things that will
reflect in it.

#2 - Add shading
and begin to develop
details

This might seem tricky, but if you take it step by step and <u>look</u> at
what you're seeing it will fall into place.

#3 - Refine
details, add
secondary
reflections.

these lines suggest
reflections in the
water

reflection breaks up
somewhat away from what cast it

Landscape With People

#1 – Plan your composition – here, I got my figures closer than I wanted and not the right size in relationship with each other

#2 – Adjust relationships and begin adding values.

#3 – Note that now their heads are closer to the same height – that's a key to placing people at different distances in a landscape. Finish details and values.

too much difference in height throws off perspective

too close

Defined the foreground figure better

more space

Remember that trees almost always look darker than grass!

Paler trees

fence reinforces perspective

Cast shadows

People cast shadows, too! →

Simple Still Life in Colored Pencil

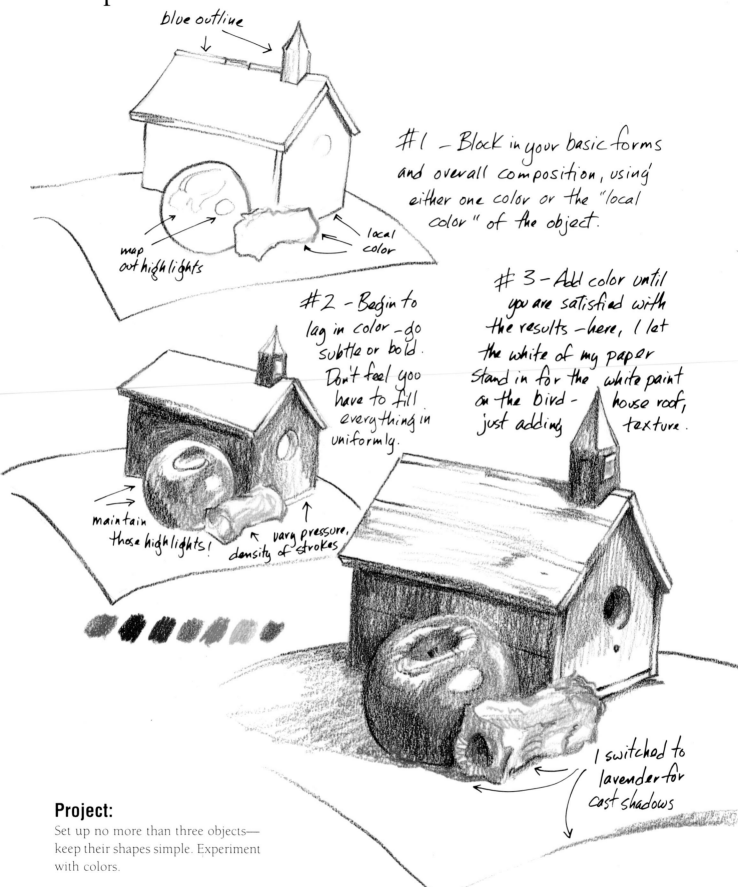

blue outline

map out highlights

local color

#1 – Block in your basic forms and overall composition, using either one color or the "local color" of the object.

#2 – Begin to lag in color – do subtle or bold. Don't feel you have to fill everything in uniformly.

maintain those highlights!

vary pressure, density of strokes

#3 – Add color until you are satisfied with the results – here, I let the white of my paper stand in for the white paint on the bird-house roof, just adding texture.

I switched to lavender for cast shadows

Project:

Set up no more than three objects—keep their shapes simple. Experiment with colors.

Use Color

Far hills may be quite blue

Things tend to get simpler, less detailed, and bluer as they recede into the distance

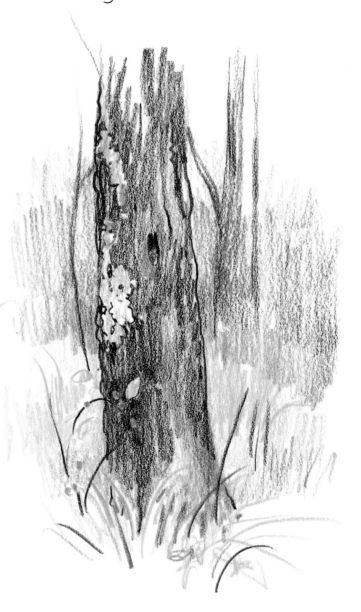

Color can be one of your best tools to suggest the way our atmosphere affects the way we see distant objects. It works with the big picture (as above) and with the more intimate landscape, like the tree at right. (Of course, I exaggerated slightly for effect.) This is another example of AERIAL PERSPECTIVE.

Landscape With Trees
and Barn in Color

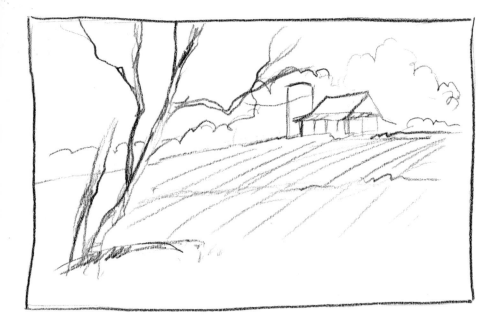

1 – Plan out your composition – on paper or in your head. Make a small thumbnail sketch if you like.

#2 – Try water-soluble colored pencils for a change. Lay in the first layer of color dry — don't be afraid to go fairly bright, and perhaps a little bit unconventional.

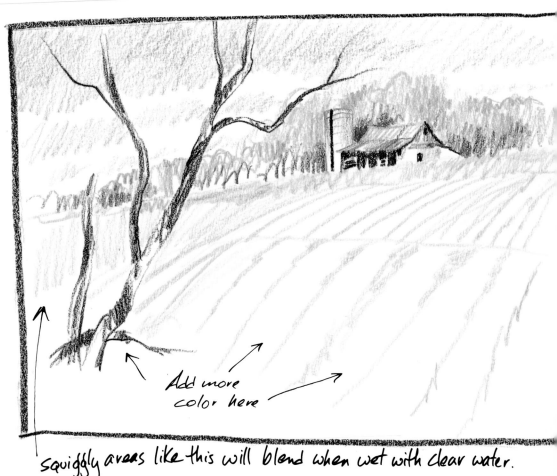

Add more color here

squiggly areas like this will blend when wet with clear water.

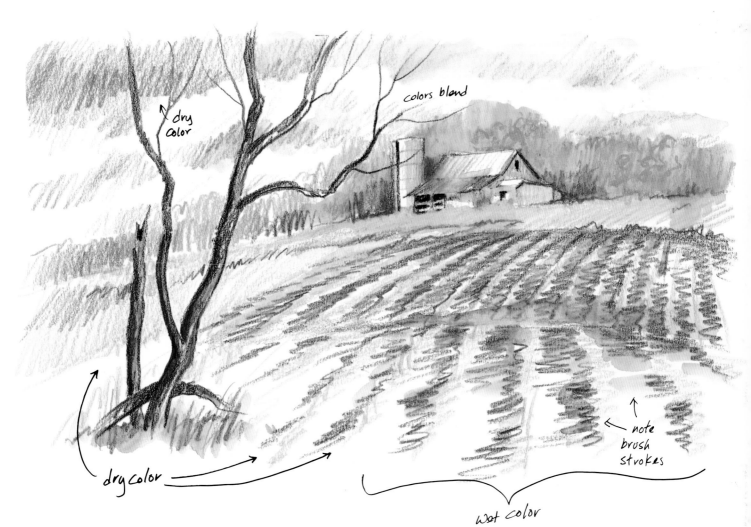

#3 — Finish adding dry color. Don't be afraid to leave some areas plain white paper— it adds sparkle. Now get out a watercolor brush and clean water. Wet a little at a time, letting the area of the drawing to suggest how you use the brush for instance, broader strokes in the sky, short horizontal strokes in the foreground. Again, leave some white paper. If you want, go back while it's damp and add some lines, or wait till it's dry, as I did with the twigs in the foreground tree.

Reflective Water in Color

Not surprisingly, watercolor works very well to suggest a wet subject like this. I chose to do a watercolor wash over a drawing done with a black Prismacolor pencil for that reason.

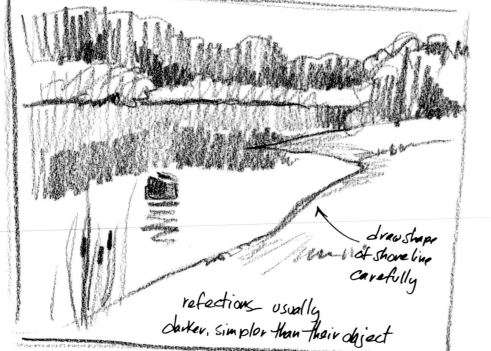

draw shape of shore line carefully

refections usually darker, simpler than their object

#1-Draw in your scene—be it a lake, pond, or quiet river. (Remember, water that is moving rapidly doesn't reflect anything!.) Establish a basic value Pattern.

#2 - Lay in quick, wet washes in the trees, sky, shoreline, and grassy banks. Let your colors bleed into one another a little. Leave the water alone until everything is dry.

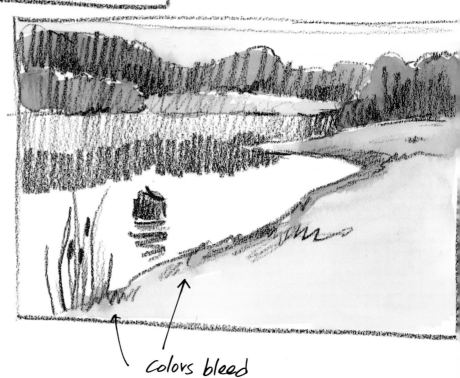

Colors bleed

#3 — Lay in an area of light blue for the water. While it's still wet, make a stroke of lighter green close to the far shore (still darker than the vegetation, though), then another, darker stroke for the reflection of the darker trees. Let these blend somewhat with each other and with the blue. Add a bit of brown at the near shore, and the reflection of the stump.

Let all this dry, then scrape out a few sparkles with a sharp craft knife. Paint the cattails and the stump with turtle and you're done. It's really simple and delightfully fresh.

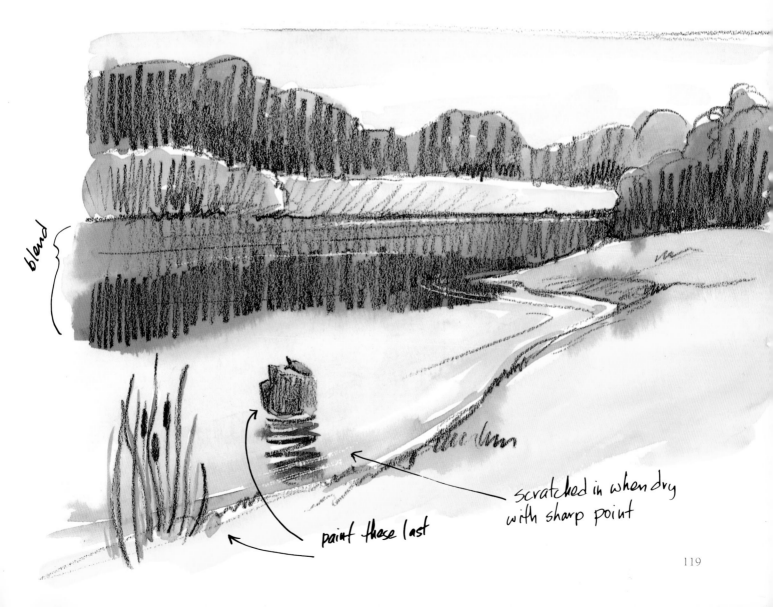

blend

paint these last

scratched in when dry with sharp point

Snow Scene in Color

#1 – Plan your composition and rough in forms. Use a pencil that won't compete too much with the final colors.

#2 – Begin laying in color – keep it loose – but _colorful_.

If you're using something really bright, like this cardinal, as a center of interest, you may want to sketch it out first to check accuracy.

plan out snowy spots – keep paper white

green suggests lichen

NOT EXACTLY COLORLESS!

#3 – Refine detail and add color until you're happy with the effect.

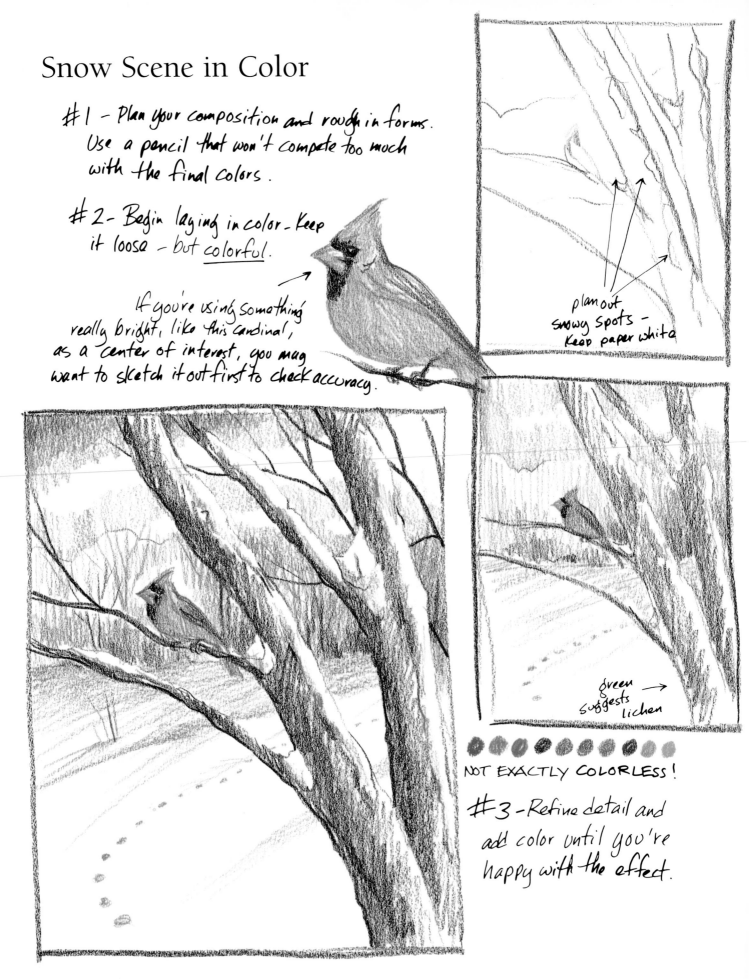

Index

More Great Books
for Artists!

Drawing Expressive Portraits—Create life-like portraits with the help of professional artist Paul Leveille. His easy-to-master techniques take the intimidation out of drawing portraits as you learn the basics of working with pencil and charcoal; how to draw and communicate facial expressions; techniques for working with live models and more! *#30746/$24.99/128 pages/281 b&w illus.*

Creating Textures in Colored Pencil—Add new dimension to your colored pencil work with these techniques for creating a rich variety of texture effects. More than 55 lifelike textures are covered, using clear, step-by-step demos and easy-to-do techniques, plus special tricks for getting that "just right" look! *#30775/$27.99/128 pages/175 color illus.*

1997 Artist's & Graphic Designer's Market—This marketing tool for fine artists and graphic designers includes listings of 2,500 buyers across the country and helpful advice on selling and showing your work from top art and design professionals. *#10459/$24.99/712 pages*

The Best of Colored Pencil III—Inspiration is just a page turn away with this collection of winners and exhibitors from the most recent Colored Pencil Society of America art shows. More than 200 imaginative drawings represent a wide array of subjects, styles and techniques—all presented in brilliant detail. *#30784/$24.99/160 pages/200+ color illus.*

Basic Figure Drawing Techniques—Discover how to capture the grace, strength and emotion of the human form. From choosing the best materials to working with models, five outstanding artists share their secrets for success in this popular art form. *#30564/$16.99/128 pages/405 b&w illus./paperback*

First Steps Series: Painting Watercolors—Discover everything you need to begin painting! Exercises will help you loosen up and learn the ins and outs of putting paint on paper. Step-by-step directions and a dozen demonstrations will show you how paintings come together, from initial sketch to final brush stroke. *#30724/$18.99/128 pages/150 color and b&w illus./paperback*

Drawing Nature—Discover how to capture the many faces and moods of nature in expressive sketches and drawings. In addition to learning specific pencil and charcoal techniques—such as circular shading, angular buildup, cross-hatching and blending, you'll learn how to work with different materials and surfaces and how to render the most common elements of outdoor scenes. *#30656/$24.99/144 pages/237 b&w illus.*

Perspective Without Pain—A hands-on guide featuring simple language and exercises to help you conquer your fears about perspective in drawing. *#30386/$19.99/144 pages/185 color illus./paperback*

Basic Drawing Techniques—Seven outstanding artists, including Bert Dodson, Charles Sovek and Frank Webb, share their drawing techniques and teach you how to use popular drawing mediums. *#30332/$16.99/128 pages/128 illus./paperback*

How to Draw Lifelike Portraits from Photographs—Using blended-pencil drawing techniques, you'll learn to create beautiful portraits that only look as though they were hard to draw. *#30675/$24.99/144 pages/135 b&w illus.*

Keys to Drawing—Proven drawing techniques even for those of you who doubt your ability to draw. Includes exercises, chapter reviews and expressive illustrations. *#30220/$21.99/224 pages/593 b&w illus./paperback*

Sketching Your Favorite Subjects in Pen & Ink—The first complete guide—for all types and levels of artists—on sketching from life in pen and ink. Written by Claudia Nice, a master of the subject, this book is presented in easy-to-follow, step-by-step fashion. *#30473/$22.95/144 pages/175 b&w illus.*

The Complete Book of Caricature—Extensive samples from top professionals combine with step-by-step lessons and exercises to make this the definitive book on caricature. *#30283/$18.99/144 pages/300 b&w illus.*

How to Draw and Sell Cartoons—Discover the secrets to creating all types of cartoons, including political! *#07666/$21.99/144 pages/74 color, 300+ b&w illus.*

The Pencil—Paul Calle begins with a history of the pencil and discussion of materials, then demonstrates trial renderings, various strokes, making corrections and drawing the head, hands and figure. *#08183/$21.99/160 pages/200 b&w illus./paperback*

The Complete Colored Pencil Book—Bernard Poulin's comprehensive book offers everything from how to buy the right tools, to how to draw rich landscapes and create textures, to how to outfit a portable studio. *#30363/$27.99/144 pages/185 color illus.*

The Very Best of Children's Book Illustration—Spark your creativity with nearly 200 reproductions of the best in contemporary children's book illustration. *#30513/$29.95/144 pages/198 color illus.*

The Colored Pencil Pocket Palette—This handy guide packed with color mixes ensures you'll pick the right colors—every time! *#30563/$16.95/64 pages/spiral bound with spine*

Realistic Figure Drawing—Based on the principles of drawing first established in the Renaissance, author Joseph Sheppard shares his technique in this illustration-packed book. *#30305/$19.99/144 pages/200 b&w illus./paperback*

Basic Still Life Techniques—Following the instructions and advice of 20 esteemed artists, you'll discover the secrets of form, value, lighting and composition that are essential to creating fine still lifes. *#30618/$16.99/128 pages/250 color illus./paperback*

The Figure—Through step-by-step illustrations and instructions, Walt Reed shows you how to simplify the complex figure into a variety of basic shapes. *#07571/$18.99/144 pages/160 b&w illus./paperback*

Basic Portrait Techniques—Roberta Carter Clark, Jan Kunz, Claudia Nice, Charles Sovek and six other noted artists show you how to capture the essence of your subject while creating realistic portraits in all mediums. *#30565/$16.99/128 pages/150+ color illus./paperback*

Setting the Right Price for Your Design & Illustration—Too high prices will drive clients away and too low prices will cheat you out of income. Easy-to-use worksheets show you how to set the right hourly rate plus how to price a variety of assignments. *#30615/$24.99/160 pages/2-color throughout/paperback*